DISCARDED

COWS: A CLOSER LOOK

COWS: A CLOSER LOOK

A Photographic Essay

Paul W. Thoresen

Published by Borderland Books, Madison, WI
www.borderlandbooks.net

Publisher's Cataloging-In-Publication Data

Thoresen, Paul W.

Cows : a closer look : a photographic essay /
Paul W. Thoresen.— 1st ed.

p. : chiefly ill. (some col.) ; cm.

Includes bibliographical references.

ISBN: 978-0-9815620-9-4

1. Cows—Pictorial works. 2. Photography, Artistic.
3. Photography of livestock. I. Title.

TR729 .C68 T46 2011
779.32/964
2011922900

Printed in the United States of America
First edition

Designed by Ken Crocker
Printed by Capital Offset Company

For cows everywhere,
 And for those who care for them.

 May they be safe and protected.
May they be healthy in mind, body, and spirit.
 May they be peaceful and at ease.
 May they be happy.

 –Buddhist Metta (loving-kindness) blessing

Only the very pure souls can take birth as a cow. The very space occupied by a cow is holy ground.

-From Hindu Gho Puja (cow ritual prayer)

Contents

Introduction

Cows and Me

I took my first picture of a cow in 1955 when I was 13. Growing up in Saylesville, Wisconsin, a small community in the heart of rural Waukesha County dairy land, I was armed with a Brownie Hawkeye, my very first camera. Reclining in the backyard was our family Guernsey, Bonnie. The one and only source of milk for our family of eight, she was loved and well cared for. She posed graciously for her portrait, and the moment was captured forever on film. That event marked the beginning of a passion for photographing these fascinating animals that has continued for more than five decades.

So why the fascination with cows? Some of the reasons are rational. Most are soulful. As a very little boy, I would watch the cows grazing in the field less than 30 feet from my bedroom window. I recall being both afraid and in awe of these huge, horned beasts. Sometimes, I would sneak under the fence into the pasture and cautiously crawl, with my heart pounding in my ears, as close to a cow as I could bravely tolerate. If one moved toward me, I'd spin around and run away at top speed, ignoring the cow pies, and dive back under the fence, breathless with a sense of terror and pride. With time, the fears subsided and the fascination grew.

There is also the fact that being a citizen of Wisconsin has always been a heartfelt part of my personal identity. I recall as a boy sitting in the living room and singing, along with an old 78 RPM recording, the words to "Beautiful Wisconsin, *milk* and honey land, in all my dreams I see…" This was a time when every vehicle's license plate in Wisconsin was imprinted with "America's Dairyland." It was not surprising that the dairy state cow affiliation became embedded in my soul.

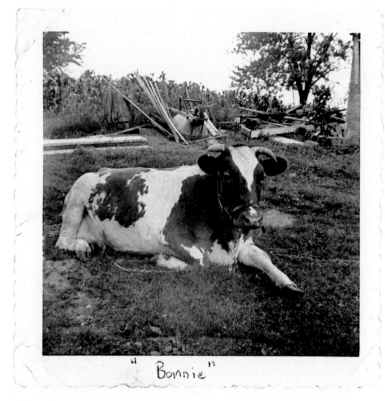

Bonnie, 1955

It's even possible that my appreciation for cows may be tied to a decadent fondness for cheese and ice cream.

Other reasons are quite clear. I continue to be drawn to the quiet, gentle presence existing incongruously in such a large, lumbering beast. I know the calm feeling when I watch a cow's slow, steady pace… with an occasional swish of tail, as it grazes across a field. I still feel a wave of youthful excitement when I arrive at a pasture and large numbers of them

gather to greet me, often vigorously sniffing and licking. I know the powerful experience of standing near a field of cows on a still, dark night and listening to the steady, rhythmic grinding crunch of grass as it is ripped from its base by the tongues and lower jaws of these bovine mowers.

Whatever the reasons, I am grateful for cows.

Besides appreciating cows for just being cows, why have I ardently continued to photograph them for decades? From the perspective of pure visual interest, cows naturally offer unlimited possibilities. They assume countless varieties of intriguing postures, poses, and expressions. Their hides offer a kaleidoscope of patterns and shapes. Cows interact in captivating ways. They invariably deliver a surprise.

I am pleased to be able to share a few of the many thousands of cow photos I have made over the past 50 years. The majority of the images in this book have been made in the past decade after returning to live in Wisconsin farm country near Paoli, just southwest of Madison. My subjects are mostly the Holsteins existing on three family farms within a mile of my home.

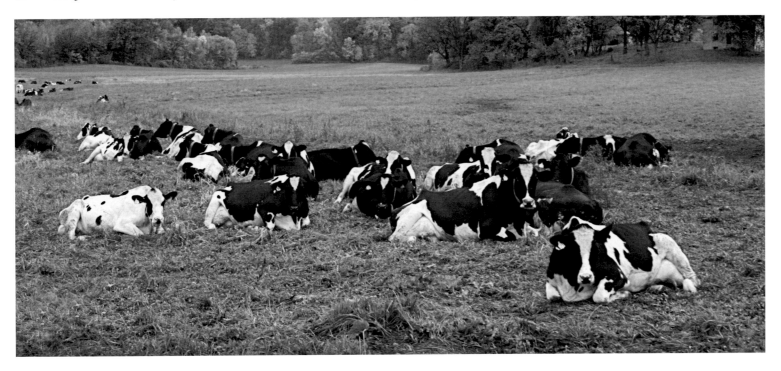

Recline, 2008

Looking Closely: An Invitation

This book is an invitation to look more closely at cows. For many of us, our knowledge of them may not extend far beyond the fact that they live on farms and produce milk. You are invited to know them more deeply.

To understand cows, we need to know their place in history and culture. Modern cows are descended from huge, wild creatures called aurochs, an animal that evolved in Asia about two million years ago. Archeological evidence indicates that early man recognized their survival value and began domesticating them at least 8,000 years ago. Within the animal kingdom, cows are relatively vulnerable creatures of prey. The ancient agreement between humans and cows has essentially been, "You provide us with milk, meat, and hides, pull our plows and carts, and we will take care of you." The impact of this contract for both parties has been major: while cows have become more docile and dependent over the centuries, they have flourished. For us, historians and anthropologists have documented that the contribution of the cow to the quality of human life has been profound (see the *Bovine References and Resources* section at the back of this book). Their importance as a food source over the course of history is obvious. Due to their inherent economic value, cows became a source for barter and trade, even a measure of one's material wealth and status. Nevertheless, cows continued through the ages to maintain a deeper, soulful connection with man, a closeness that has been reflected in art and spiritual practices for thousands of years.

In today's world, the relationship of cows to humans has unfortunately deteriorated. As the demand for beef and dairy products has increased exponentially over the past several centuries, cows have largely become objects to be developed and pushed for greater productivity. Regarded for millennia as motherly, nourishing, even mystical beings, they have gradually been reduced to well-maintained milk- and meat-producing machines. Often they become merely a source of humorous stories, cartoons, and puns. I believe that we have lost our sense of something more profound that transforms *us* when we share an interdependent relationship with an animal for 8,000 years. Our ancestors knew a deeper connection, one that is worthy of our attention and rediscovery.

This book is about exploring the very essence of cows that exists beyond words. Via the images of a photographic essay, and with a little help from supporting narrative, we will look more deeply into several dimensions of "cowness." These parameters will be viewed from diverse yet overlapping perspectives of cows: as individuals, as part of the social herd, as feminine/masculine, and as tenants of the land. We will venture a glimpse into their souls and view them as they move through time/space, as spirit/myth and as visual abstraction.

Each component section will be introduced with a brief narrative that offers a contextual backdrop for that particular parameter of cow nature. The images that follow the narrative will reveal more fully what I wish to convey about cows.

Note: The term "cow" technically refers to the female bovine only. "Cattle" is formally used to cover both male and female. In common usage, however, "cow" typically refers to both genders and, unless otherwise specified, will be used as such in this book.

A Word About the Photography

It will be evident that the images in this book represent a wide range of photographic approaches and artistic style. The creative methods have been adapted to render each facet of cow nature more adequately. Most of the photos are in black and white and were initially recorded on film. The film is made from gelatin which, appropriately enough, comes from the hooves of cows.

The images depicting cows as mystical beings, moving in space/time, were created in several ways. To render a sense of movement and mystery, multiple exposures were made on a single frame of film in a simple inexpensive camera with a plastic lens. The camera, called a Holga, is notorious for its vignetted, distorted images, and uncontrolled light leaks that can lend an ethereal tone to any image.

The rendering of the supernatural, conceptual components of the color images was facilitated by simply using a flash with the slow shutter speeds of a digital camera. There is a strong element of unpredictability in making exposures this way as well as when using the Holga. The results are often serendipitous and surprising. A sense of adventurous exploration, play, and discovery is introduced to the photographic process. It has helped me to see cows with new eyes.

Slow graze 3, 2006

The Components of Cow: A Closer Look

Individual Cow

On a weekend drive in the country, most of us are likely to first see cows within the context of a herd, congregated in a barnyard or spread out in a pasture. Depending on our time and interest, we may not pay much attention to individual animals. But if we were to take time to watch the herd a few moments longer, one or two cows might gain our attention, perhaps due to their special appearance or behavior. If we were to observe them carefully over a longer period of time, we might learn that each cow has unique behavior patterns and personality traits. A great deal can be learned from even a brief first-hand observation of and encounter with an individual cow. Since most of us aren't farmers, how might we make this happen? For a potentially rich and rewarding experience, follow the *Guidelines for Encountering a Cow* on page 127.

Cow Psyche

While we may not be able to know exactly what it's like to be a cow, we can gain some sense of it by carefully observing them and their behavior. We know, for example, that cows can see with 320-degree panoramic vision, hear acutely at frequencies both above and below ours, and can detect smells five miles away. A cow's tail position signals its physical and emotional states. When relaxed, grazing or walking, the tail is straight down. When tucked between its legs, the cow is likely to be fearful, sick, or cold. A cow will tend to isolate itself from the herd when it is sick or in pain.

Cows share a great deal with humans in their response to stress and comfort levels. When stressed, their bodies release hormones that weaken their resistance to disease and decrease lactation. Cows give more milk when they are comfortable, with suitable bedding and cool, pleasant weather. Yields increase when they are given names, treated kindly, and spoken to affectionately. Productivity also increases when they are exposed to the soothing sounds of Beethoven's Pastoral Symphony, as opposed to the harshness of hard rock.

Cow Individuality

Cows are ultimately individuals. At first glance, that is evident even in their appearance. With many breeds, individual cows can easily be identified simply by noting the patterns in their hide. The specific markings, which remain the same throughout a cow's life, are sufficiently unique to be comparable to the identifying power of a human fingerprint. A cow's distinctiveness is further enhanced by the way its hide is sculpted via the animal's interior structure.

Besides individual behavior patterns and personalities, most dairy farmers are primarily concerned with the practical aspects of a cow's individuality, mainly its productivity and manageability. But farmers vary in the extent to which they respond to the "personhood" of their cows. This is reflected in how they identify their individual animals. Most often, expecially in larger herds, each cow is really known only by the identification number tagged in its ear. Some farmers, however, make the effort to add fitting names for each of their ladies, such as Specks, Elsie, or Hannah. She might be number 47, but she's really Daisy to us.

Encountering an Individual Cow

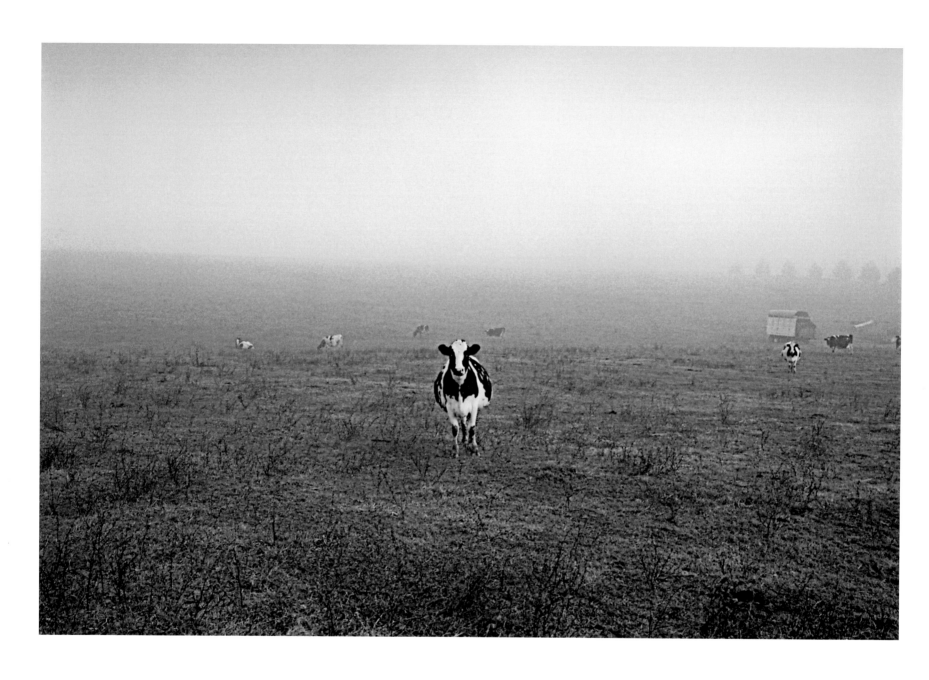

Specks in the field, 2002

Meeting Specks, Meeting Myself

I awoke early one November morning to see a thick fog bathing the countryside in a soft, muted glow that only fog can create. The light being a personal favorite for photographing, I grabbed my camera and headed straight for the nearest neighbor's pasture to see if the cows were out.

As soon as I entered the pasture, I was stopped short by the sight of a single spotted Holstein at the far end of the field. She seemed to simultaneously sense my presence, lifted her head, and began looking directly at me. I immediately felt a curious connection with this animal, this creature who seemed alone and apart from the herd. She began to walk slowly in my direction, never taking her eyes off of me. I anxiously checked to see if this was a cow or a bull. Reassured by the presence of an udder, I stood my ground and began to photograph, alternating between maintaining eye contact and watching her briefly through the viewfinder before pressing the shutter. What was this creature up to? Was *she* wondering the same thing?

The cow would take a few steps forward, stop, and for a few eerie moments simply stare at me. The pattern continued until she finally stopped about five feet away, directly facing me. Just what was this dirty-kneed lady, whom I later learned was named Specks, trying to tell me? As we stood looking at each other, it almost seemed that she knew something important about me that I needed to understand. It occurred to me that if I am quiet enough, and pay attention, I might just learn what that is.

We both stood transfixed for what might actually have been only a few more moments. A point was reached when I sensed this was enough, so I bowed and silently thanked her. She lowered her head and began grazing.

As I left the field, I noticed the fog begin to lift.

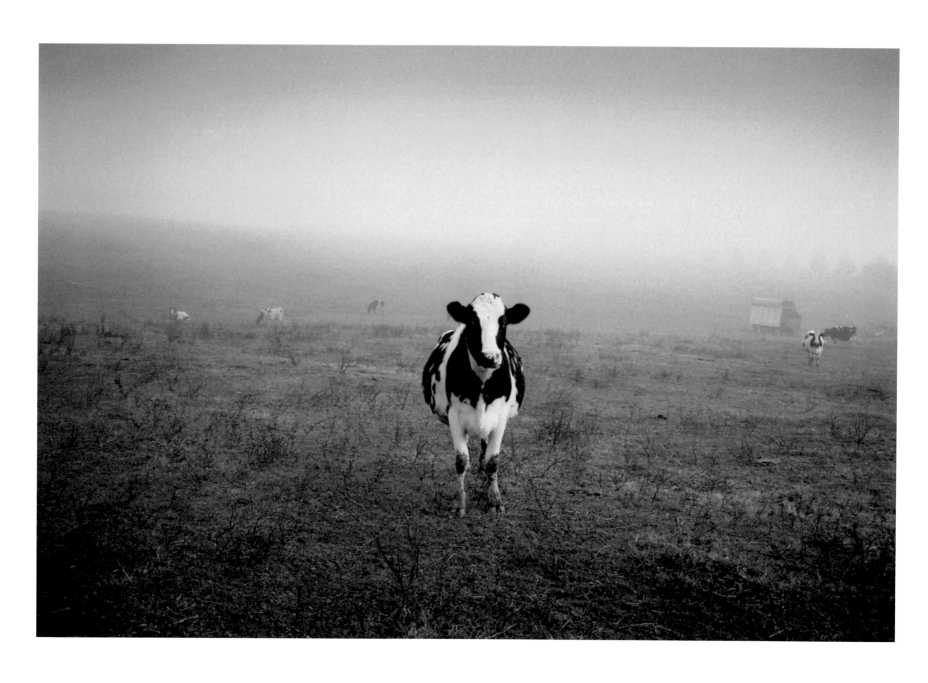

Specks approach 1, 2002

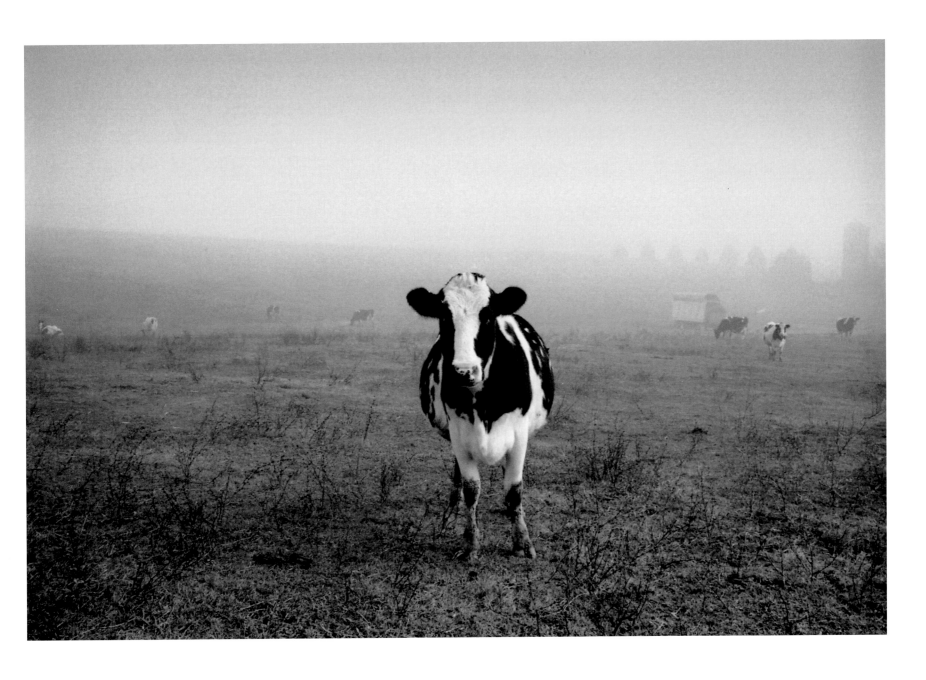

Specks approach 2, 2002

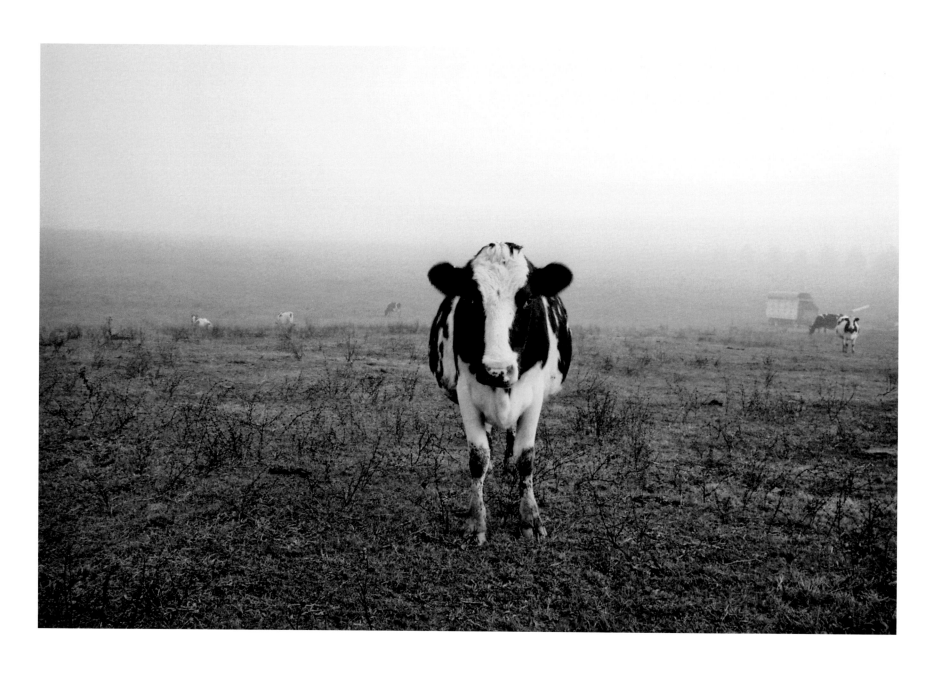

Specks approach 3, 2002

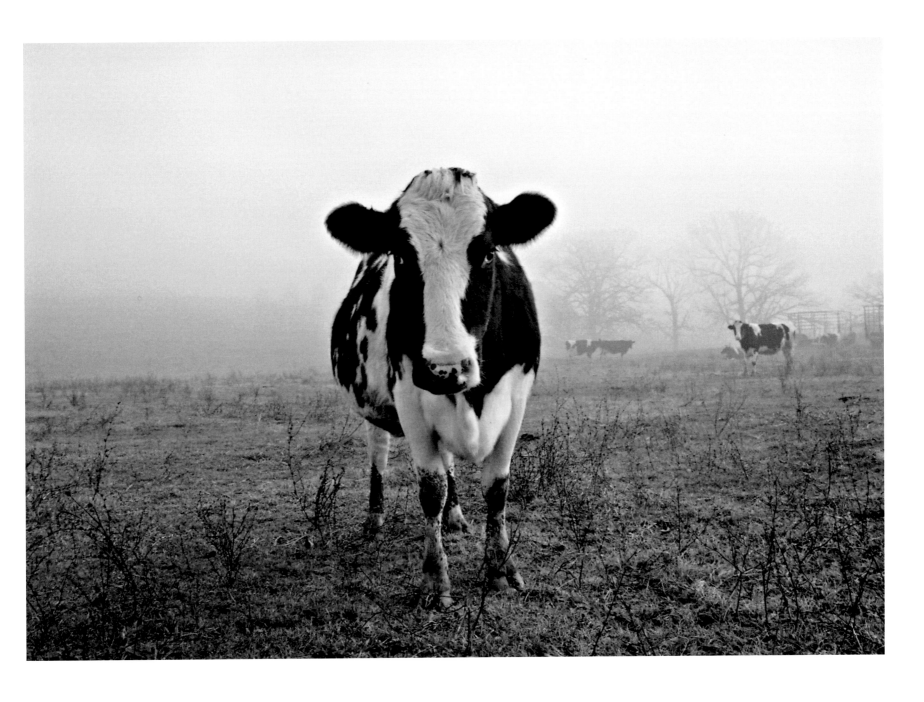

Encounter, 2002

More Individuals

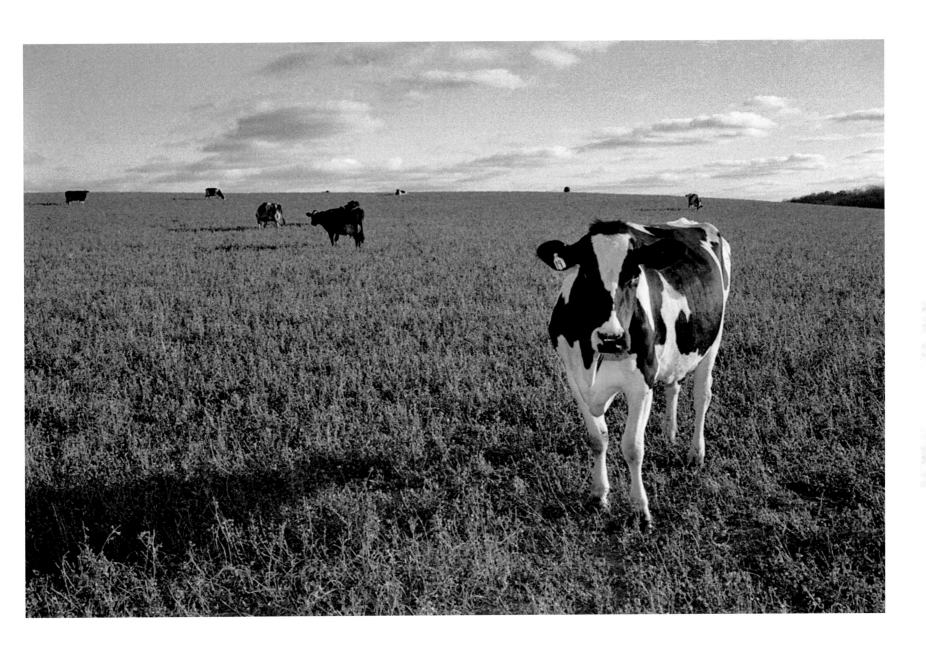

Space for number 19, 2007

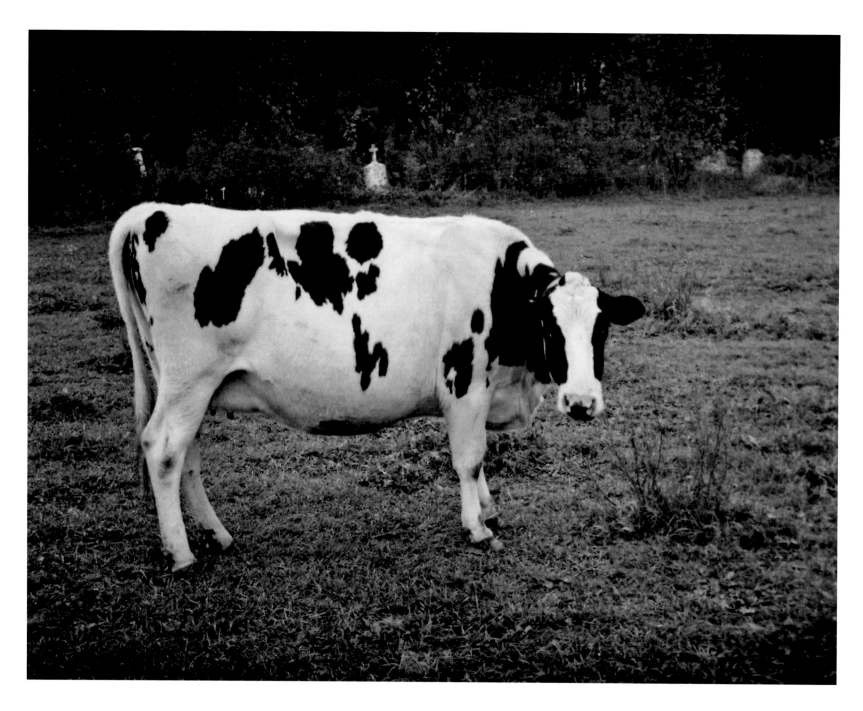

Twister, 2007

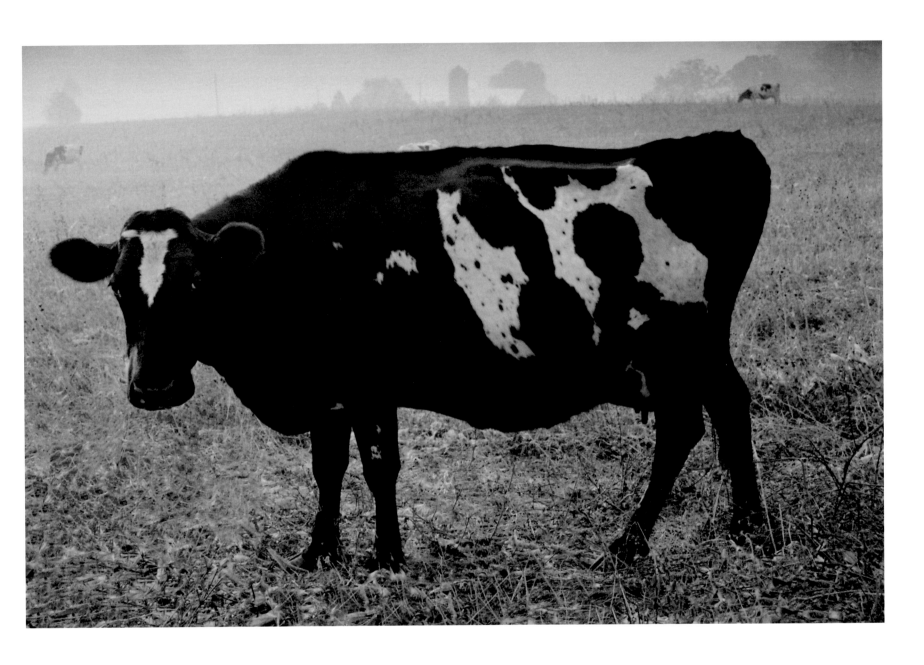

Magic, 2003

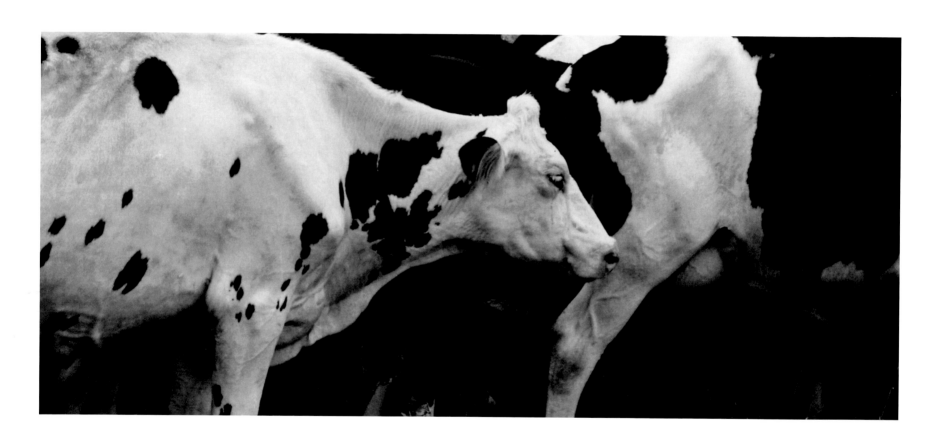

Shelly, 2005

Cow Individuality: Hide and Body Sculpture

Hide pattern...as identifying as a human fingerprint

Body sculpture...uniqueness in structural form

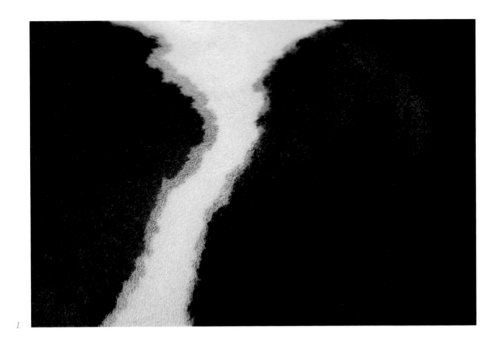

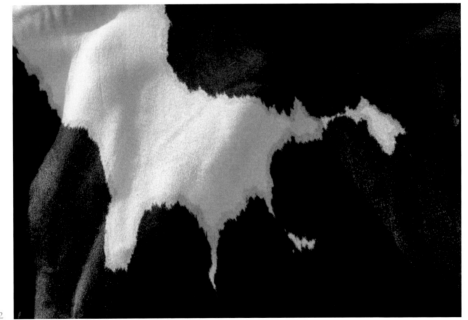

Cowhide patterns, 2009

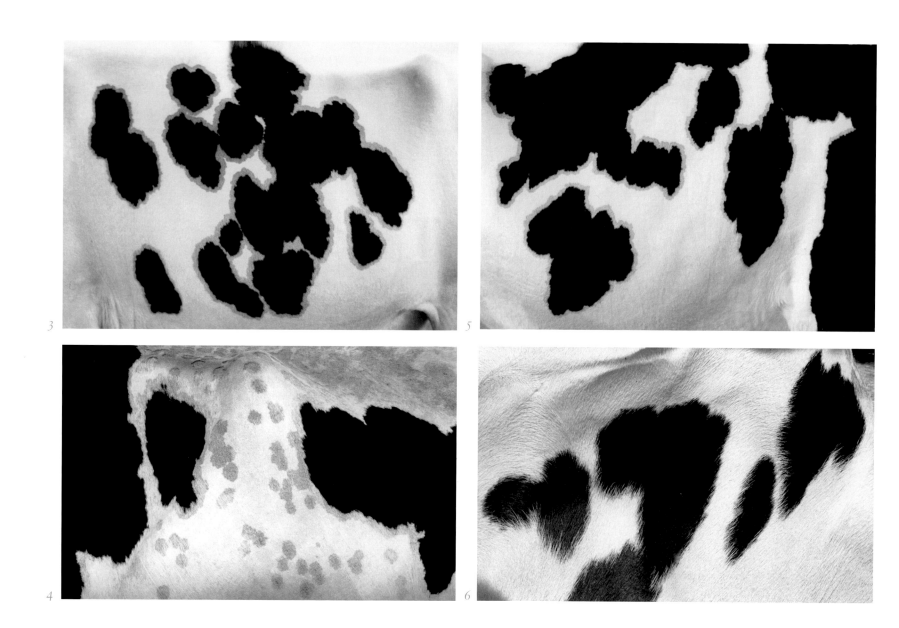

3

5

4

6

Cowhide patterns, 2008

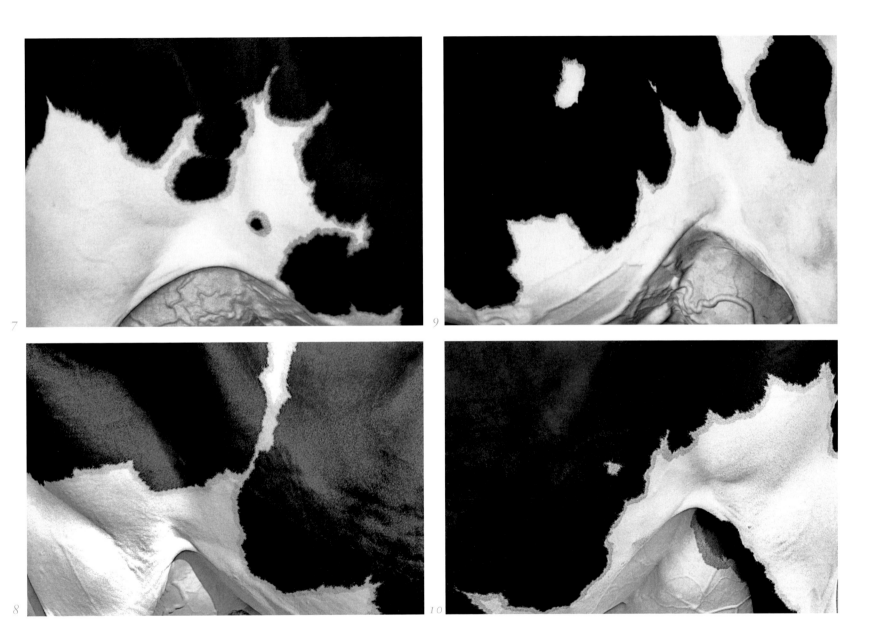

7

8

9

10

Cowhide study, 2008

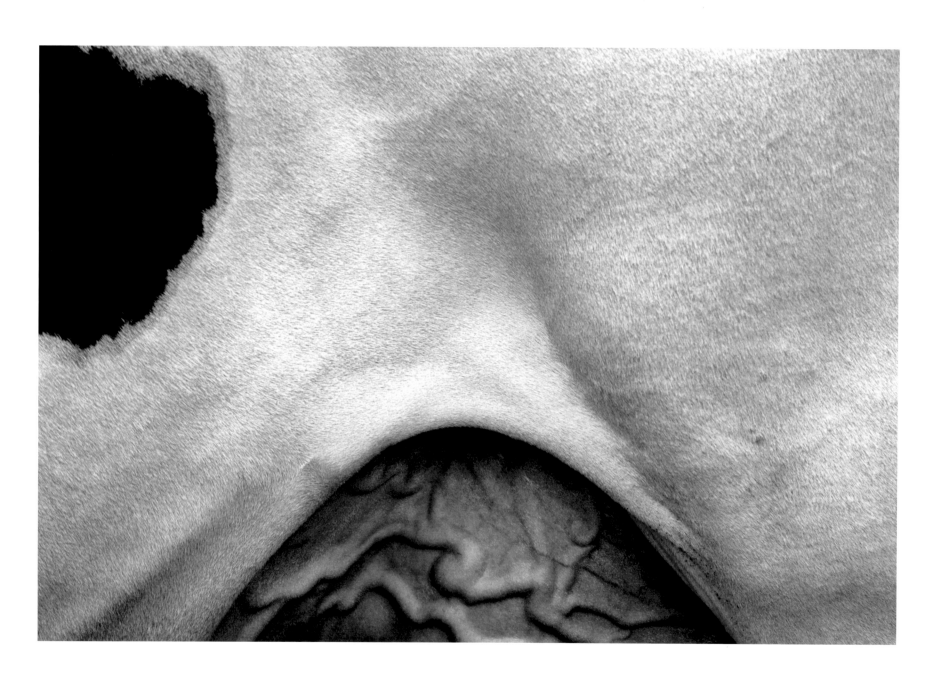

Milk vessel 1, 2008

[36]

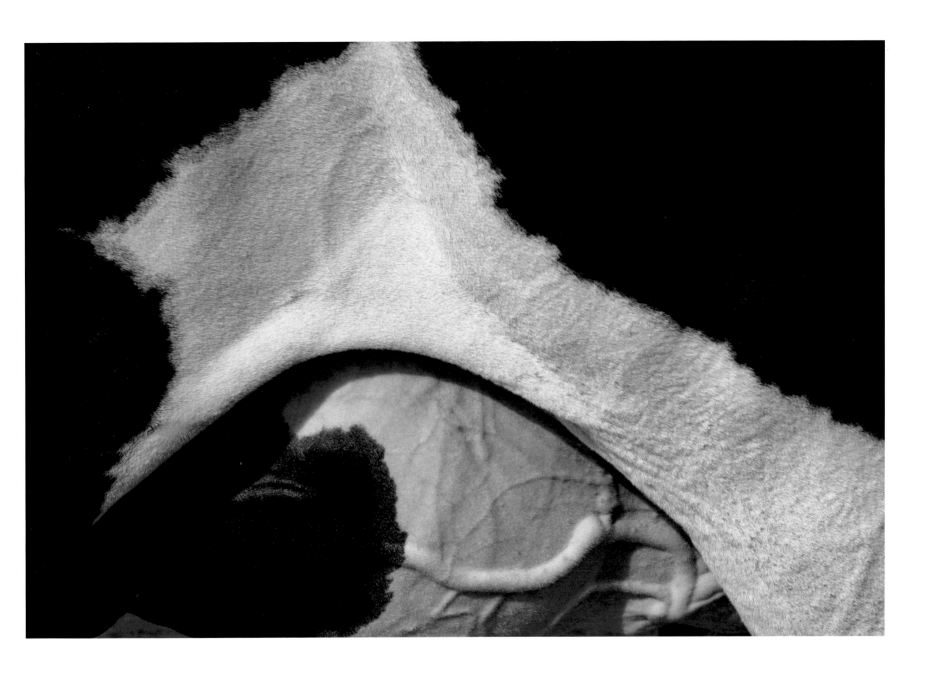

Milk vessel 2, 2008

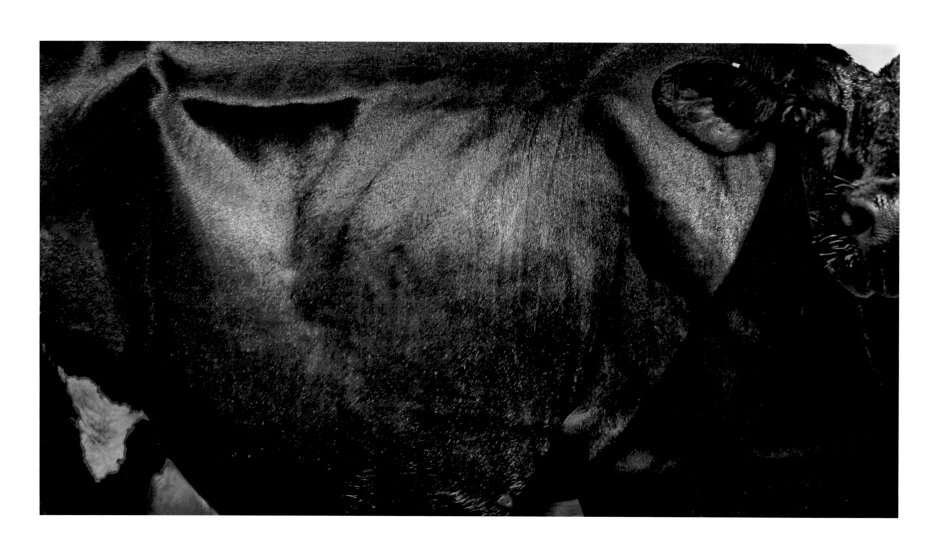

Hide sculpture study 1, 2008

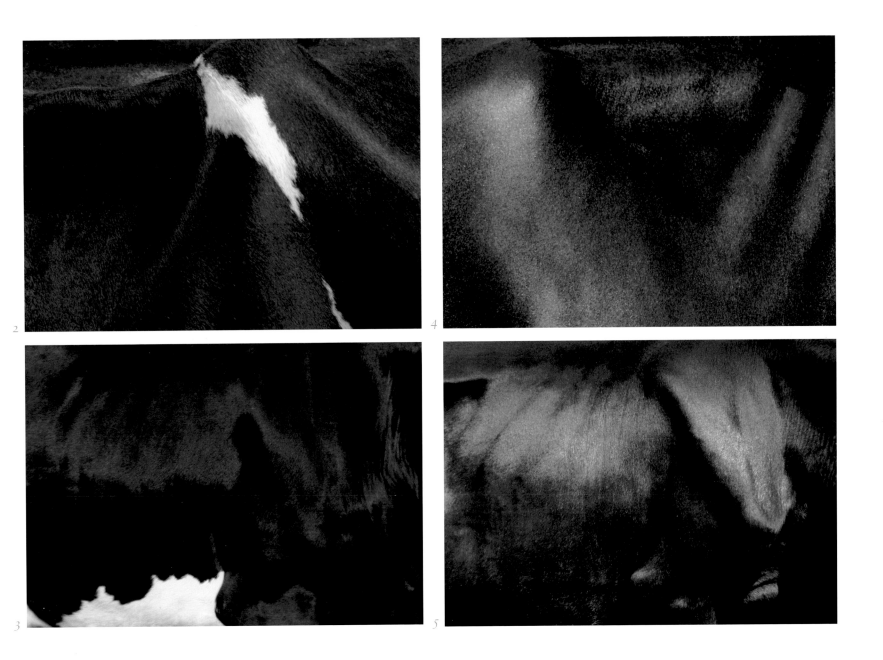

2

3

4

5

Hide sculpture study, 2008

Hide sculpture 6, with a swish of the tail, 2010

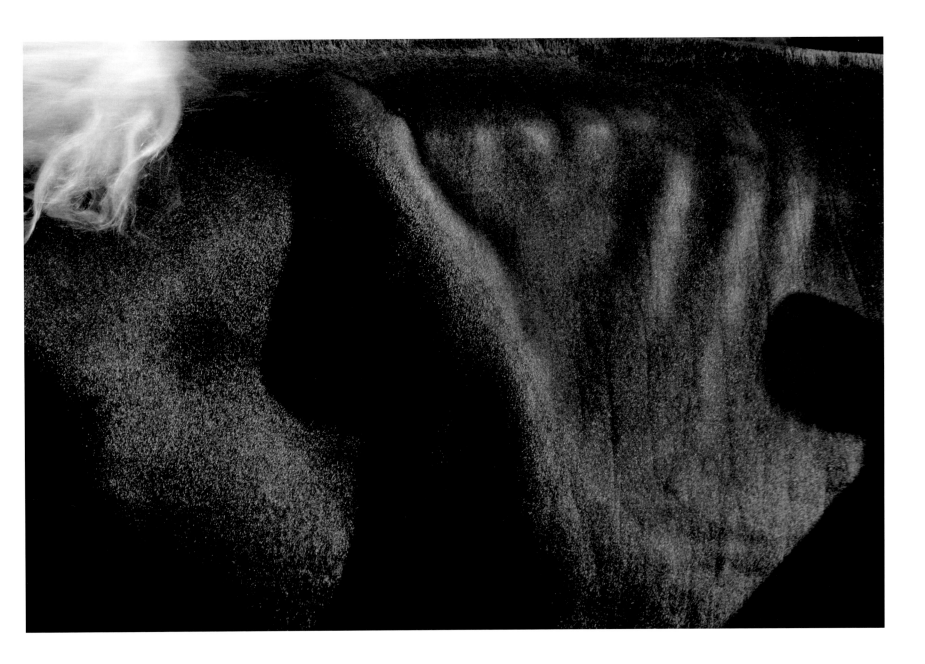

Hide sculpture in white, 2008

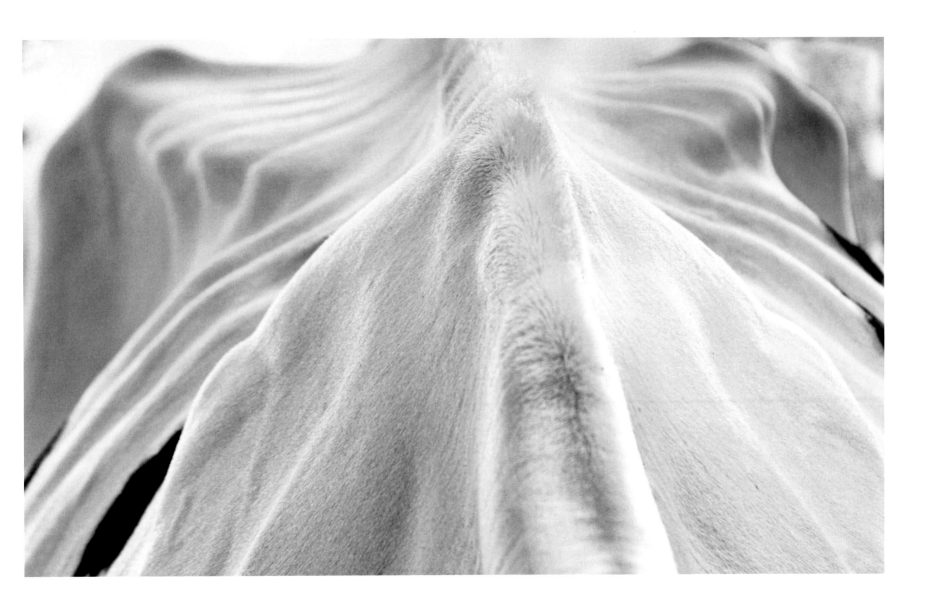

Hide sculpture in black, 2008

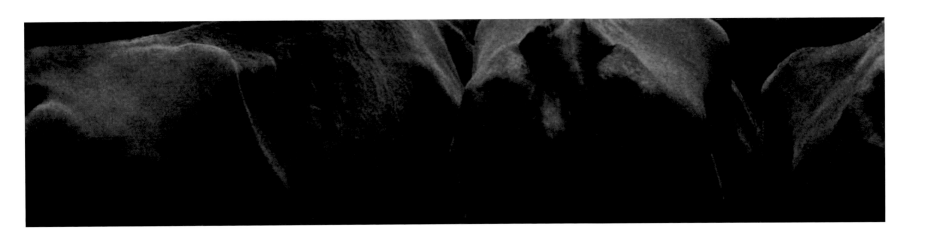

The Herd

The herd is essentially about survival. Cows are relatively docile, passive beings within the animal kingdom, and as such are vulnerable creatures of prey. Instinctually they herd together for protection. Humans fostered this herding instinct for easier management as they domesticated cows over the centuries. Feeding and milking are more efficient when cows move as a group. For reasons of economic survival over the past 60 years, herds have become larger while the number of dairy farms has shrunk dramatically. In 2009 there were less than 10 percent the number of dairy farms in the U.S. as in 1950. For the past several decades, Wisconsin dairy farms have been closing down at an average rate of three per day. Despite the rapid increase in "mega-farms" with herds numbering in the thousands, the number of cows in most dairy farms still ranges between 50 and 100 head.*

Ladies with dirty knees, 2008

While cows are relatively passive animals, within the herd one can observe more aggressive and competitive behavior. This is related to the establishment and maintenance of a positional hierarchy within that herd. There emerges a distinct alpha cow who leads and dominates the others. When a new cow first comes into a herd, she must skillfully push, kick, or shove the others in order to establish her position within that group. This will determine her leadership status and priority level for obtaining food and water, as well as any other necessities and comforts of living. In cow society, nice girls finish last.

Cows often form "cliques" within a herd. An inner group of three or four can be found spending much of their time together, frequently licking and grooming each other. As a group, they will even reject and exclude certain cows outside their circle.

*U.S. Department of Agriculture, *National Agricultural Statistic Service, Dairy Products*

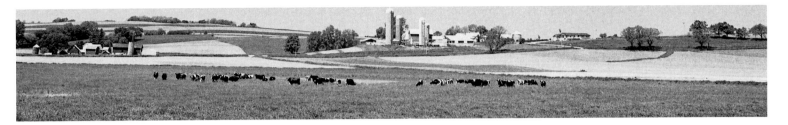

Pastural symphony: prelude, 1999

Encountering a Herd: Great Expectations

Driving on a country road a few miles north of Madison one clear June afternoon, I spotted a herd of cows grazing at the far end of a field nearly a half mile away. I stopped, stood at the fence with my camera, and watched for a moment. Suddenly, to my utter disbelief, the scattered cows, for no apparent reason, began to assemble into a single, dark band. The maneuver appeared to be orchestrated by a white spotted alpha cow who proceeded to lead them slowly in my direction. It was if she were conducting the entire herd to move toward me in a series of steady, synchronized movements. As they drew closer, the pace quickened and was reaching a crescendo when they stopped abruptly at the fence where I stood. More than forty pairs of cow eyes were fixed on me with a sense of intense expectation.

In that moment I realized that any grandiose ideas I may have entertained about why this herd had just traveled far across the field to greet me were not likely valid. These animals engage in this kind of behavior with humans because they usually are rewarded for their efforts with something they need, such as food, water, or udder relief. Having nothing to offer, I found myself embarrassed at having greatly disappointed them. This noble crowd, who traveled so far and expected so much, had been let down. I left them feeling grateful that cows are gentle, hopefully forgiving, creatures.

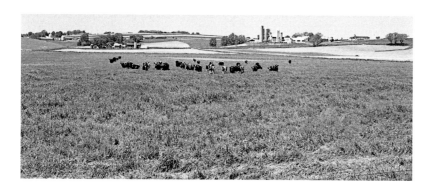 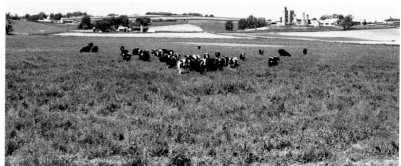

Pastural symphony: movements 1–4, 1999

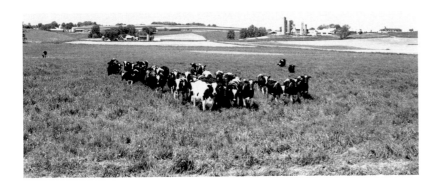 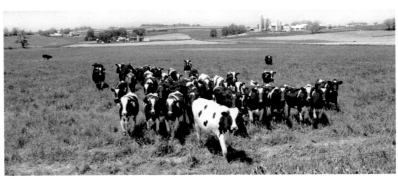

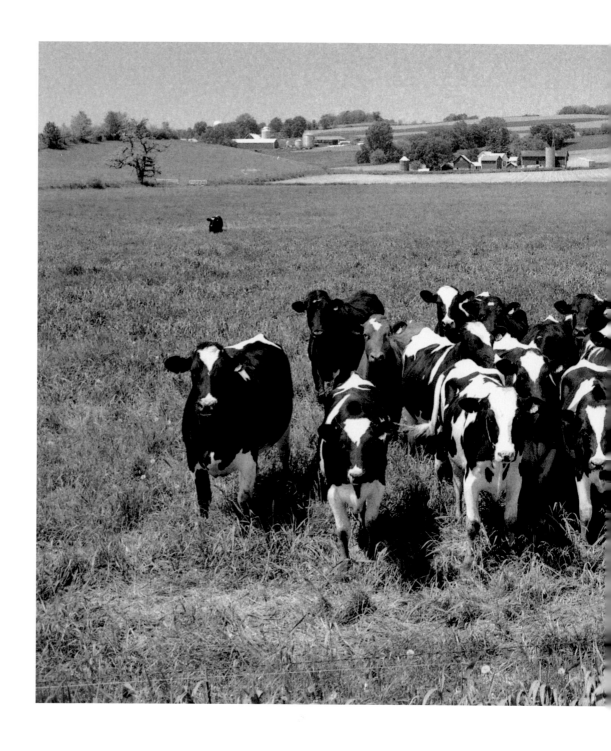

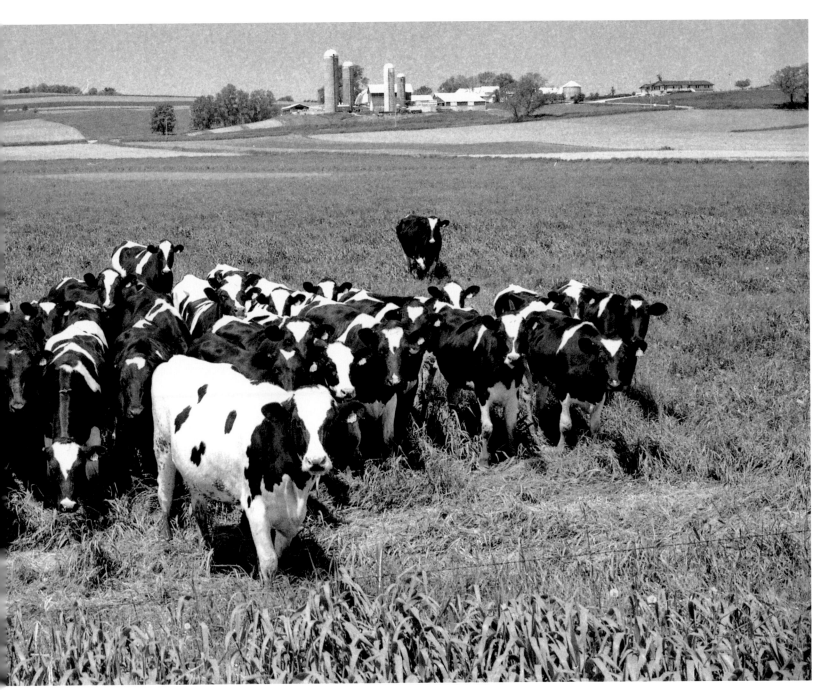

Pastural symphony: 5th movement, 1999

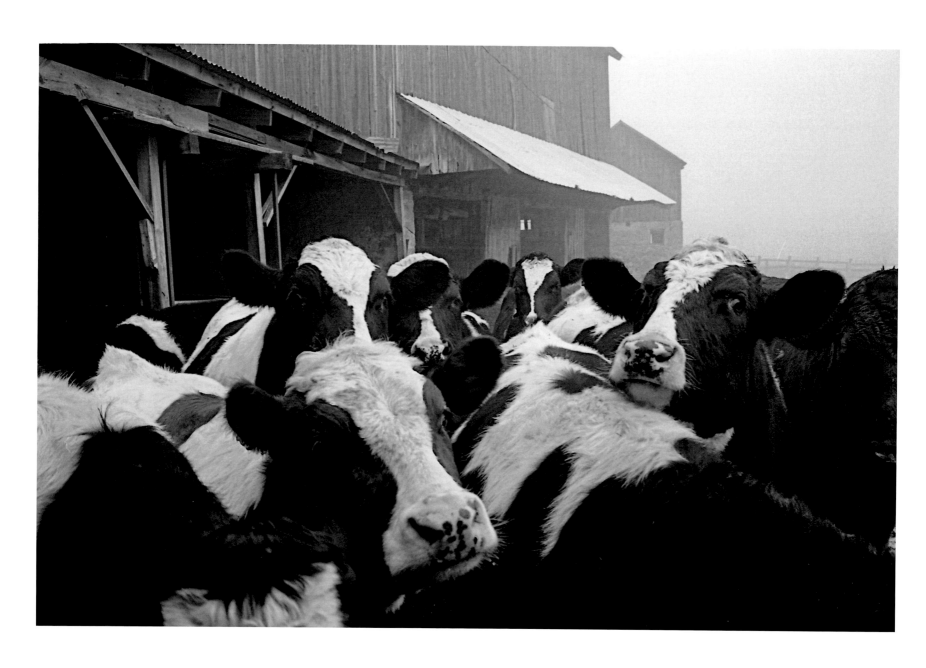

Vying within the herd 1, 2002

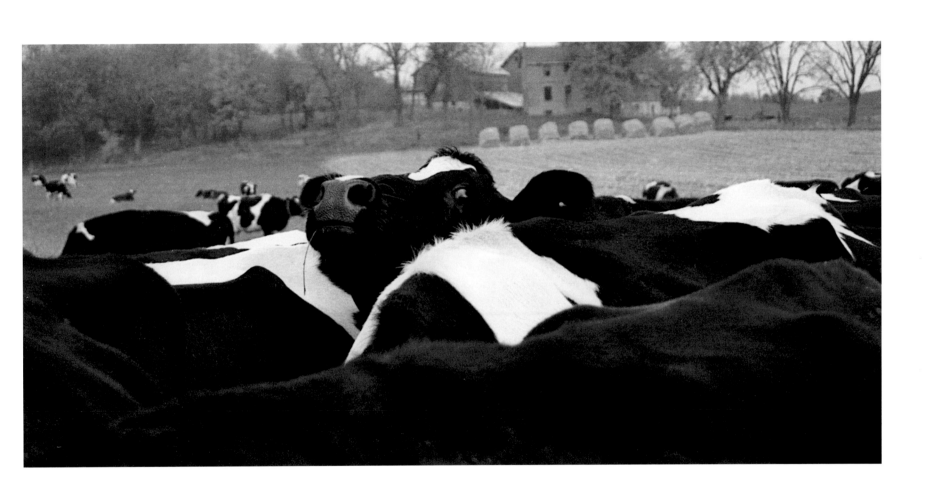

Vying within the herd 2, 2004

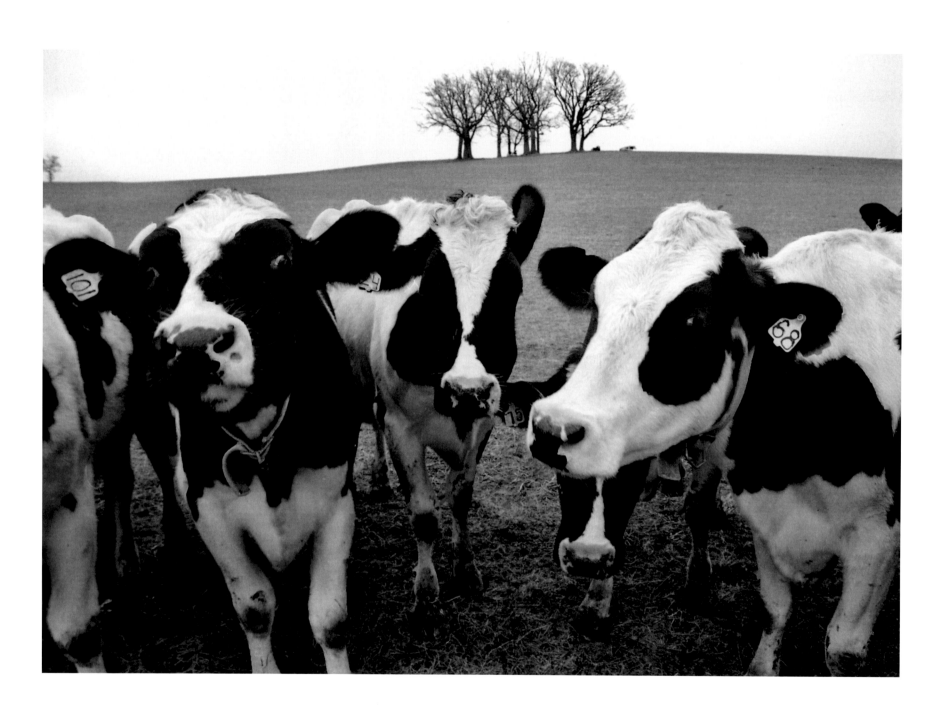

Herd group, 2002

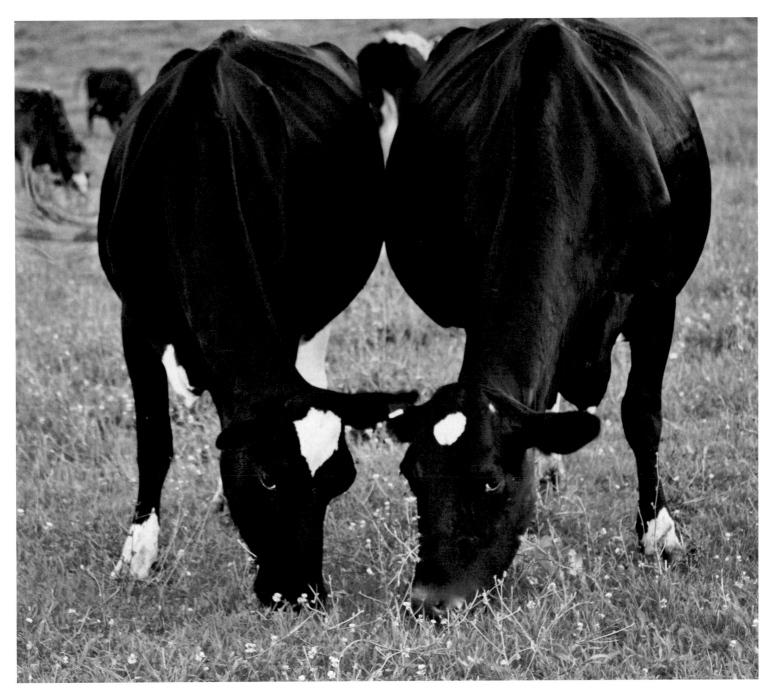

Herd pair, 2010

Feminine Bovine

Cows are female. Perhaps more than any other animal, their traits have been closely associated with many of those of the traditional human female; nurturing and giving, caring and gentle. Cows are quintessentially maternal. Like all mammals, they nurture and provide milk for their young. Because their milk supply far exceeds the needs of the calf, there is plenty left over for us. In worldwide legends, Egyptian, Hindu Indian, and Scandinavian cows are the mothers of all creatures, bestowing abundant life throughout the earth.

The distinctly female functions of a cow begin at a early age. At 15 to 18 months, a heifer is usually inseminated and about 10 months later produces her first calf. By becoming a mother and producing her first milk at the beginning of her second year, she enters full womanhood and officially becomes a cow. The maternal bond with her calf is immediately evident. Soon after birth she treats her newborn to a long, thorough licking until the calf is clean. This process helps the mother recognize and identify her calf within the herd. Mother and calf frequently call to each other for suckling. When the newborn calf is separated from her, usually within the first day, the mother's bellowing is further testimony to the bond.

Hormones play a critical role in a cow's life, being essential for reproductive function, maternal bonding, and lactation. As the cow approaches estrus in her cycle, behavior changes occur, including the occasional rear mounting of another cow, usually one that is also in estrus. Within any given herd, such cows tend to form a sexually active group, a behavior identifying them as being in heat.

Although the normal life span of a cow is 15 to 20 years, most are terminated at age five or six after producing three calves and having maximized their period of greatest milk productivity.

We humans attribute a quality of femininity to a cow's appearance. Among the extensive list of physical attributes in the formal competitive judging of dairy cattle, a cow is, in fact, evaluated for her femininity. Occasionally it is even applied to the way she moves. And of course there are the familiar cartoon images of motherly, aproned, long eye-lashed cows, such as Elsie of Borden's dairy products.

When near a Cow

One can
become aware

of a Presence

massive and nurturing and warm

Something remembered
from a time before words

when hungry
and needing to fill
the belly/heart

with comfort

 – P. W. T

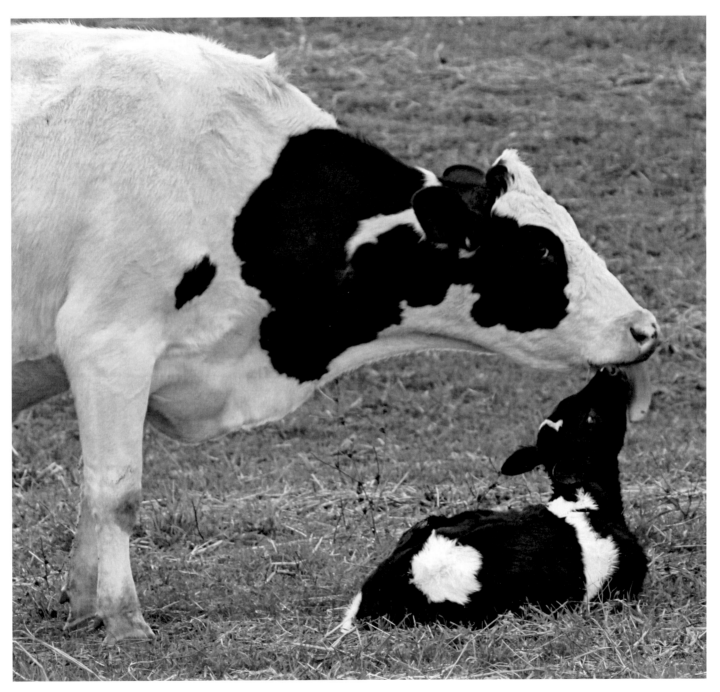

Hannah and her calf, 2009

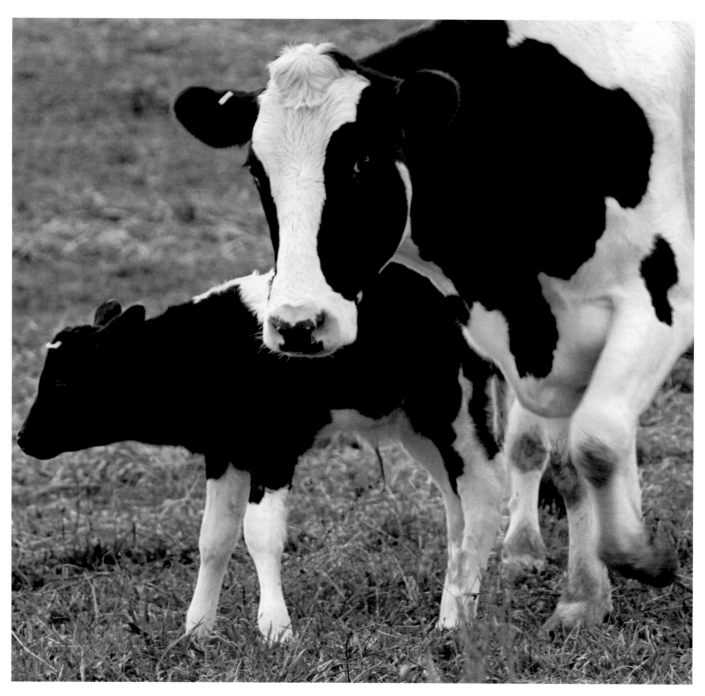

Molly and calf, 2009

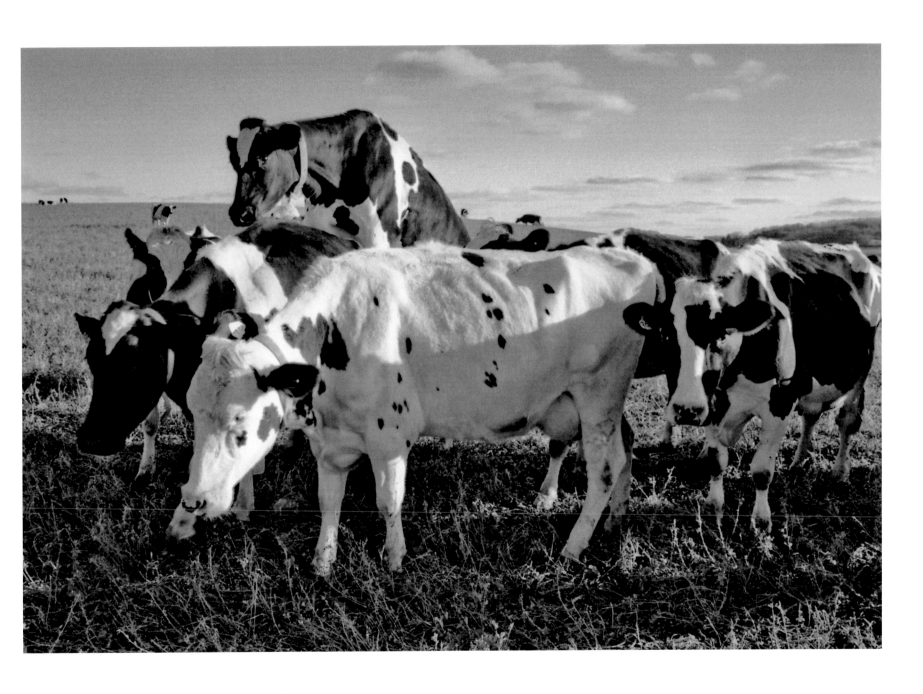

Hormones, 2007

[63]

Masculine Bovine

The Bull

When we consider the male counterpart of cows, naturally the bull comes to mind. As king of the herd and sultan of the harem, he represents the ultimate in virility, testosterone, and macho aggression.

The bulls of myth and legend over the ages are depicted in terms of absolute strength, power, and authority. Kings and rulers of earlier civilizations closely identified themselves with god-bulls who embody these qualities. The all-powerful Greek god Zeus assumed the disguise of a white bull in his seduction of Europa. The supreme god-bulls Enlil of Mesopotamia, Min of Egypt, and Indira of India all personified ferocious sexuality and fertility.

Because the bull is the epitome of ferocious strength and terrifying aggression, anyone who might challenge, engage in battle, or vanquish such a beast would naturally win admiration and respect as the ultimate courageous hero. This is the stuff of myth, legend, and ritual throughout history. It continues today with the matador in the ring and the bull rider in the rodeo.

On the dairy farm of today, a bull will seldom be found. Most dairy cows are now artificially inseminated. Fewer bulls are needed because this method enables the genetically superior semen of a single prize bull to be available to many more thousands of cows.

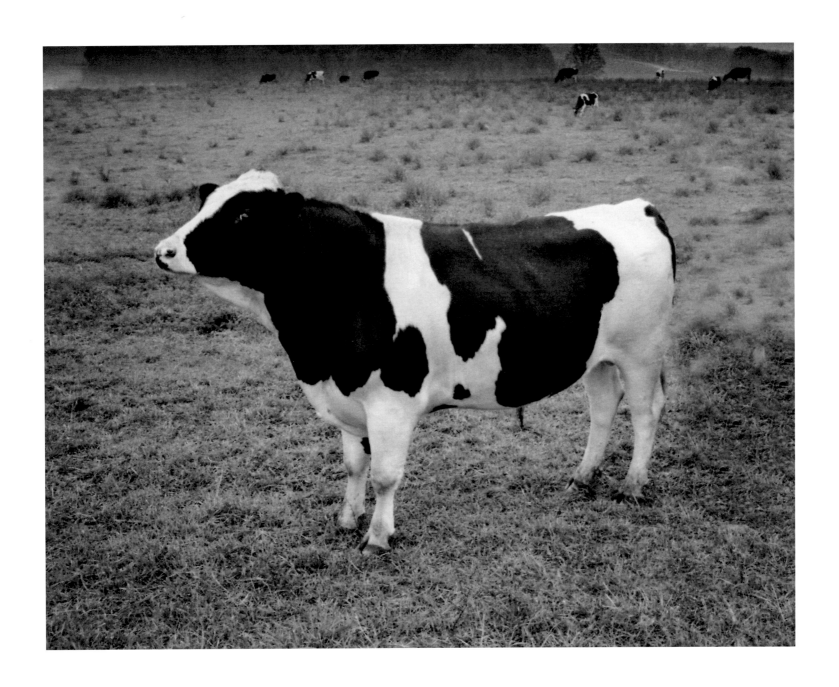

Rufus, 2007

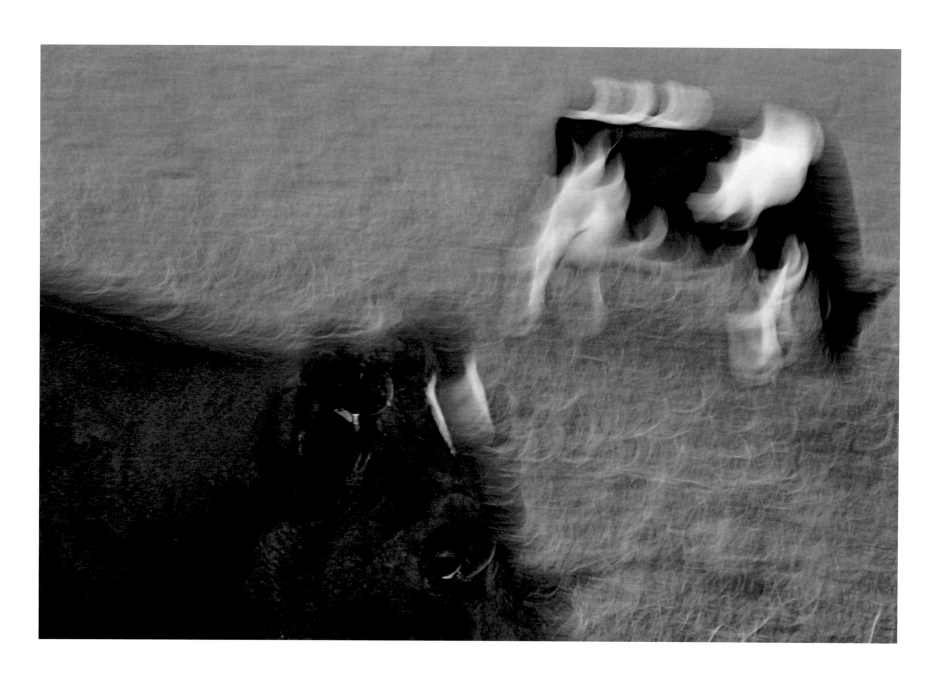

The bull and the cow, 2008

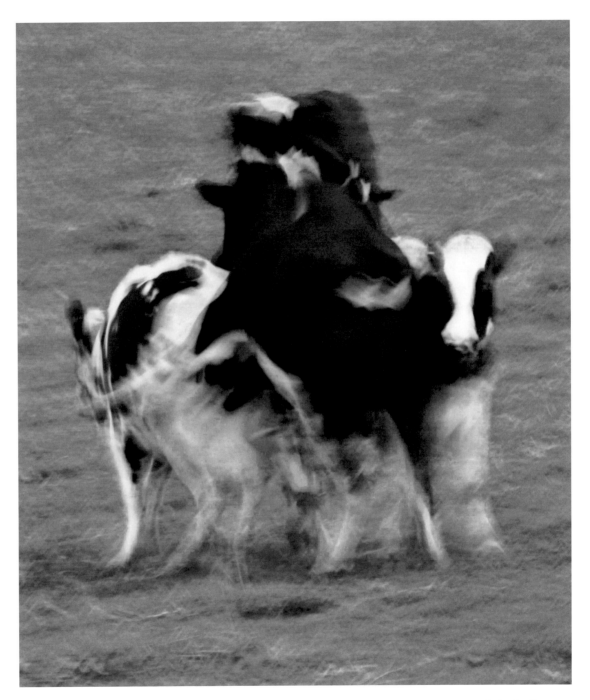

Dance of the bull, 2009

The Steer

When a male calf is born, the likelihood of its growing to maturity is quite slim. This honor belongs only to the boy-to-become-bull with the most impressive family history for siring cows with high milk productivity. By far, most of the males will realize a far less enviable destiny. Some will end up as veal only a few months after birth. Others will be castrated, dehorned, and raised as steer for meat production. Most are sold for processing at 12 to 18 months of age.

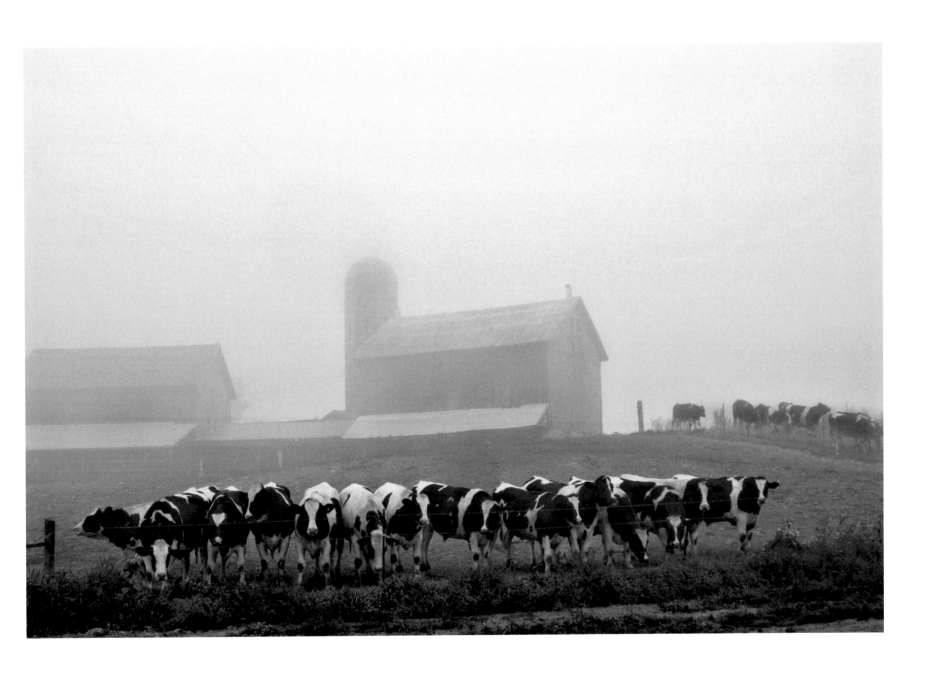

Steer: Eunuchs of dairyland, 2008

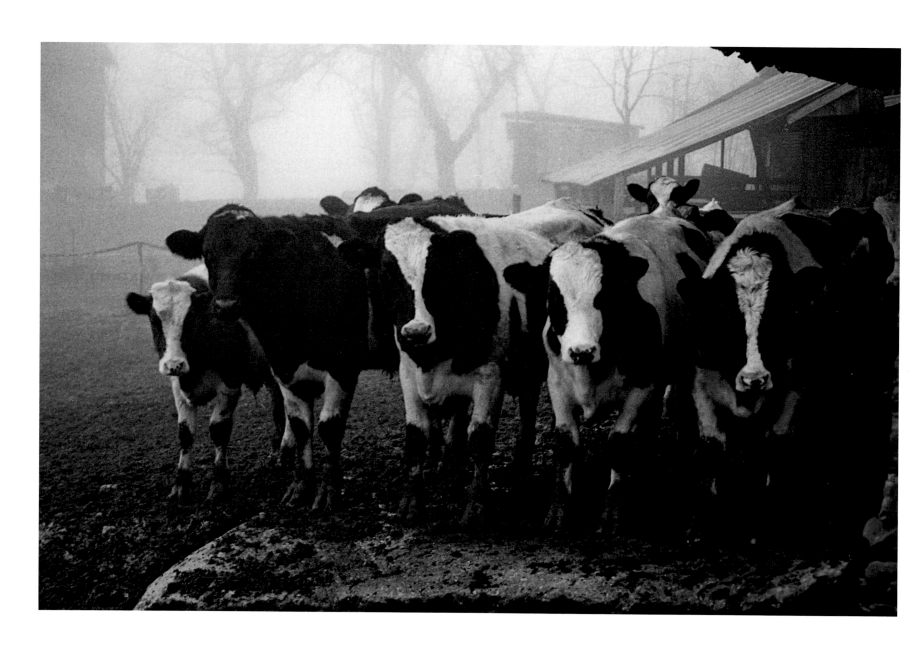

Steer brethren, 2002

[72]

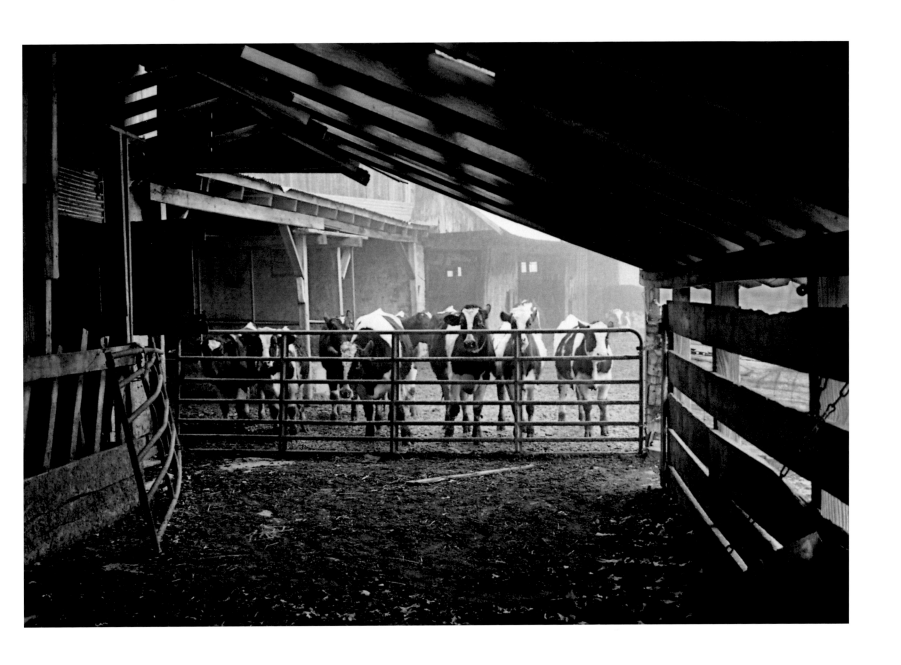

Steer at the gate, 2002

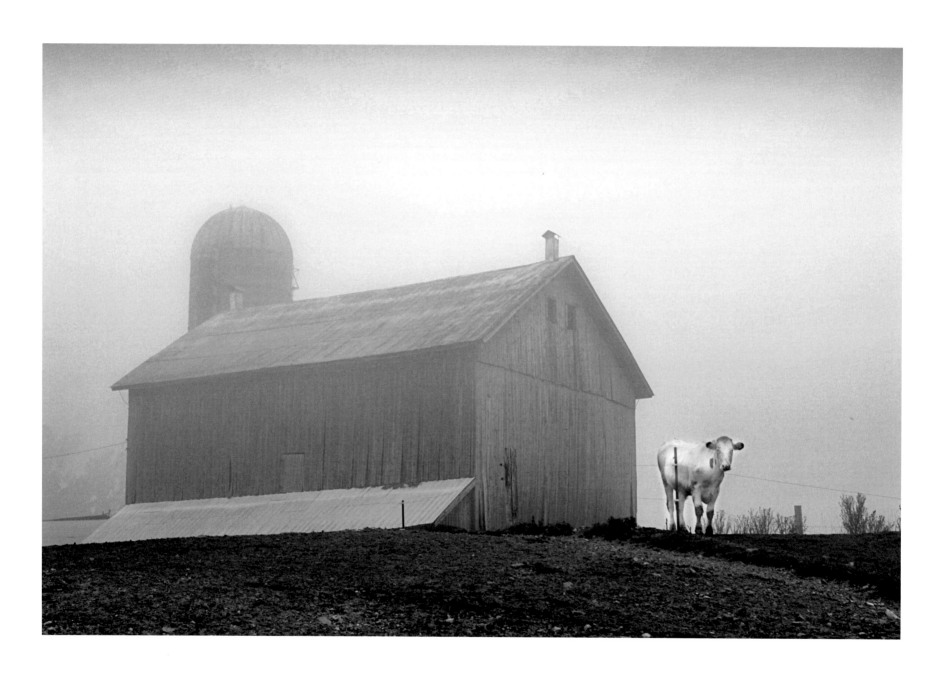

Lone steer, 2008

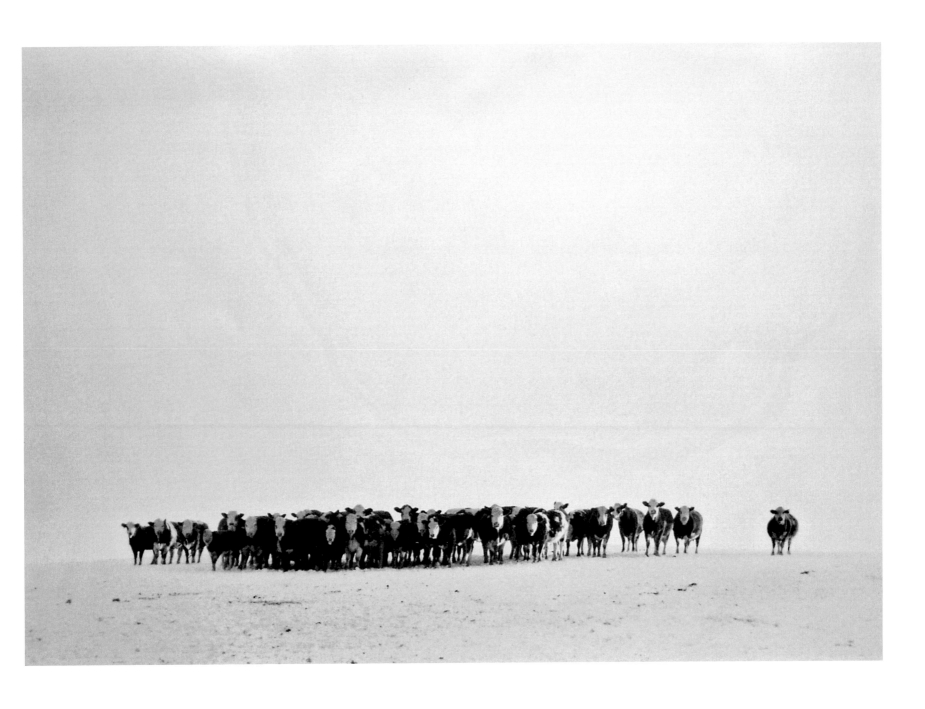

Steer herd in snow, 2003

Cow as Integral with the Land

Cows are large animals. Their common wild ancestor, the auroch, was enormous. In seventeenth-century Europe, one of the last remaining aurochs was measured to be six feet tall at the shoulder, with horns 19 inches in circumference. Today's average Holstein is about four feet at the shoulder, but still weighs in at 1,400 pounds.

Animals of this size consume and produce formidable amounts of matter and energy. As herbivores, cows rely on the earth's vegetation, devouring huge volumes of food and water daily. Unfortunately, due to shrinking pasture land availability and modernized feeding methods, cows are becoming less directly connected to the land for their food source. Cow product and energy consumption-production issues continue to be thoroughly studied and intensely debated, especially with regard to efficiency and health benefits, as well as the impact upon the earth itself.

Cow manure, for example, fortunately serves as potent fertilizer, enhancing the productivity of many varieties of crops dramatically. When managed skillfully, it enriches the earth. Unfortunately, we have learned in recent decades that cow manure and digestive gases release methane into the air in amounts that are contributing significantly to the breakdown of the protective ozone layer in our atmosphere. Fortunately, extensive research is underway for reducing the methane in cow gas and developing efficient methane "digesters" that convert the gas into usable energy resources.

For better or worse, the dairy cow's relationship to the earth is changing and complex. Fortunately, it is still easy to find a field of them grazing in a green pasture, a natural part of the landscape, blending with the earth itself.

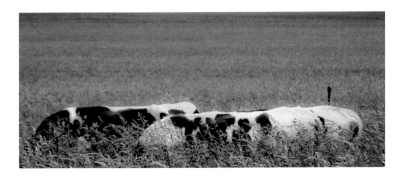

Deep graze, 2010

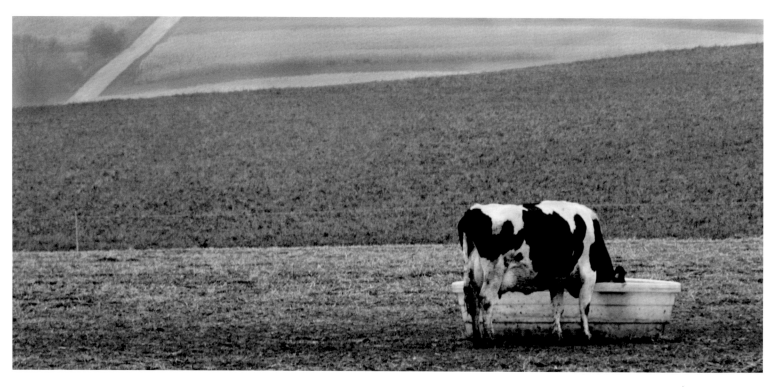

Intake, 2008

Daily Cow Intake and Output

In one day the average cow consumes:
 100 pounds of food
 417 pounds of water (50 gallons)

to produce:
 54 pounds of milk (6.3 gallons)

and eliminate:
 65 pounds of manure.

Source: U.S. Department of Agriculture Statistics, April 2008.

the Cow

takes from gives back to

is One with

the Earth

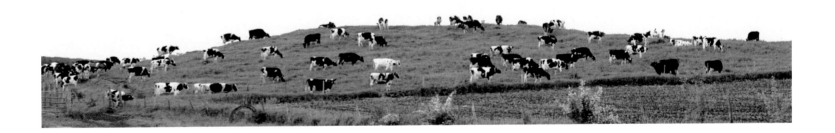

Cow hill, 2008

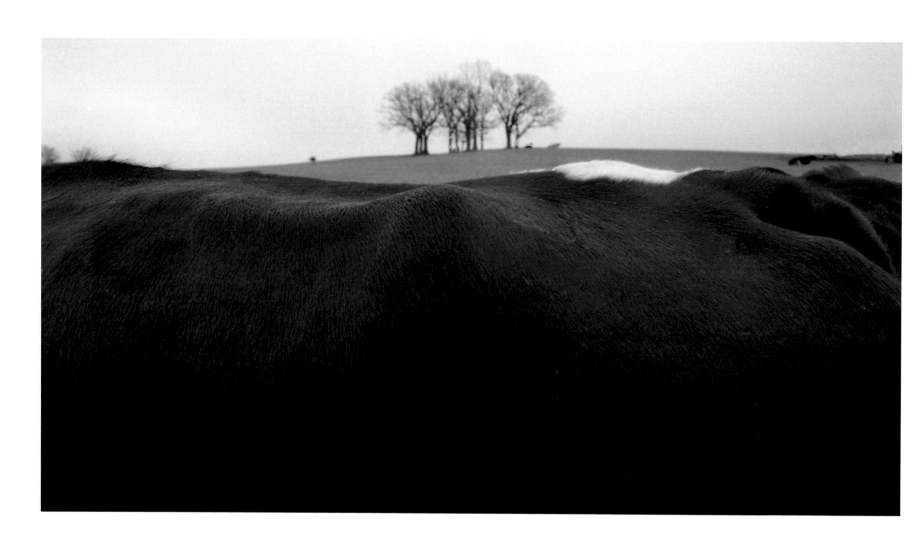

Cowscape 1, 2005

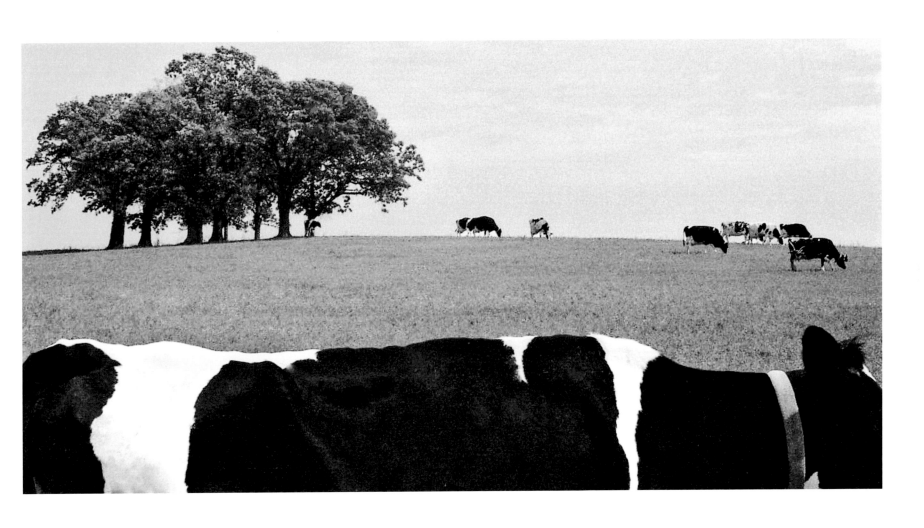

Cowscape 2, 2005

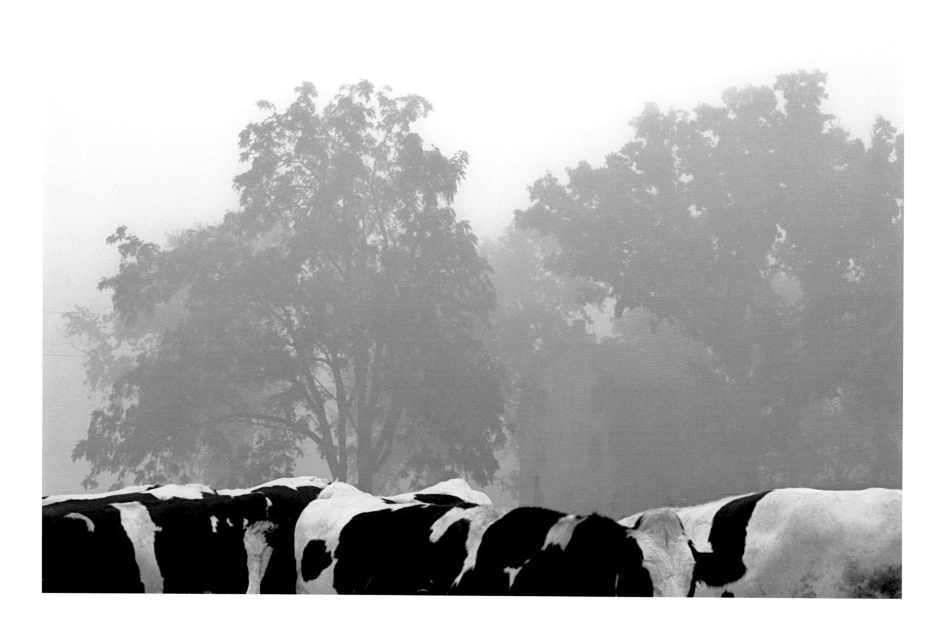

Cowscape 3, 2008

[82]

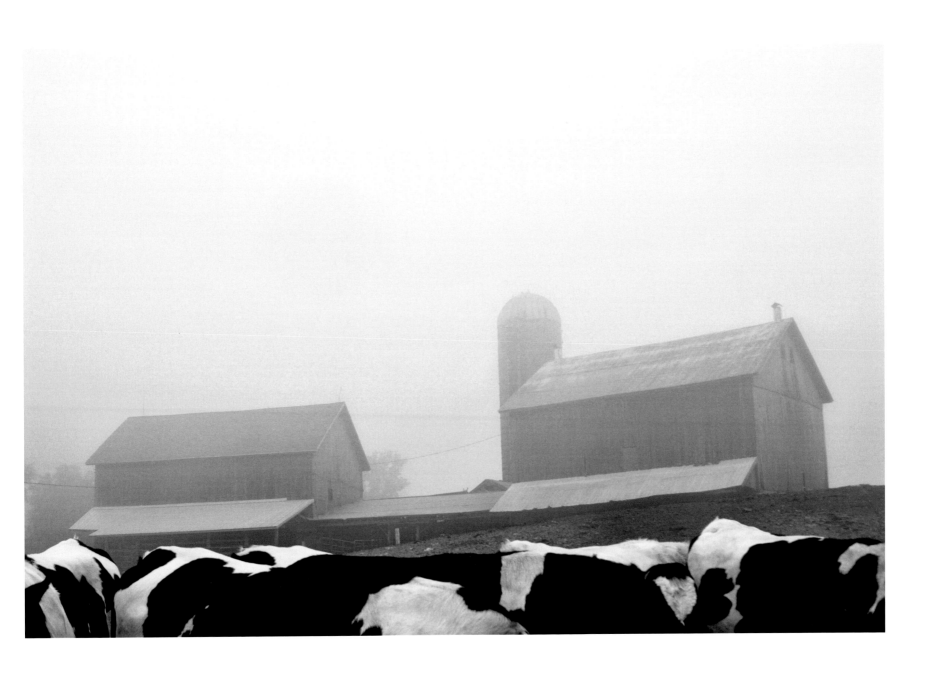

Cowscape 4, 2008

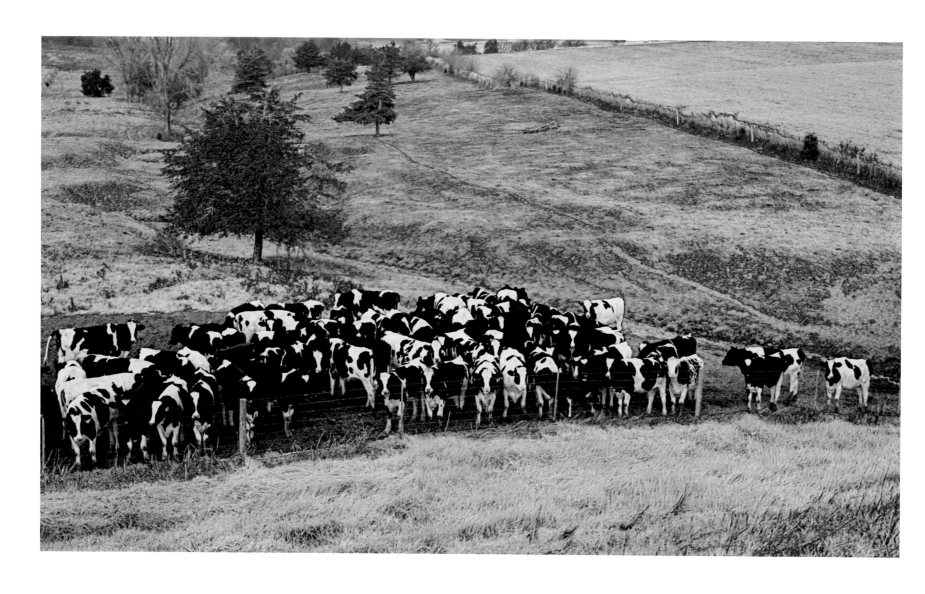

Herd, early frost, 2002

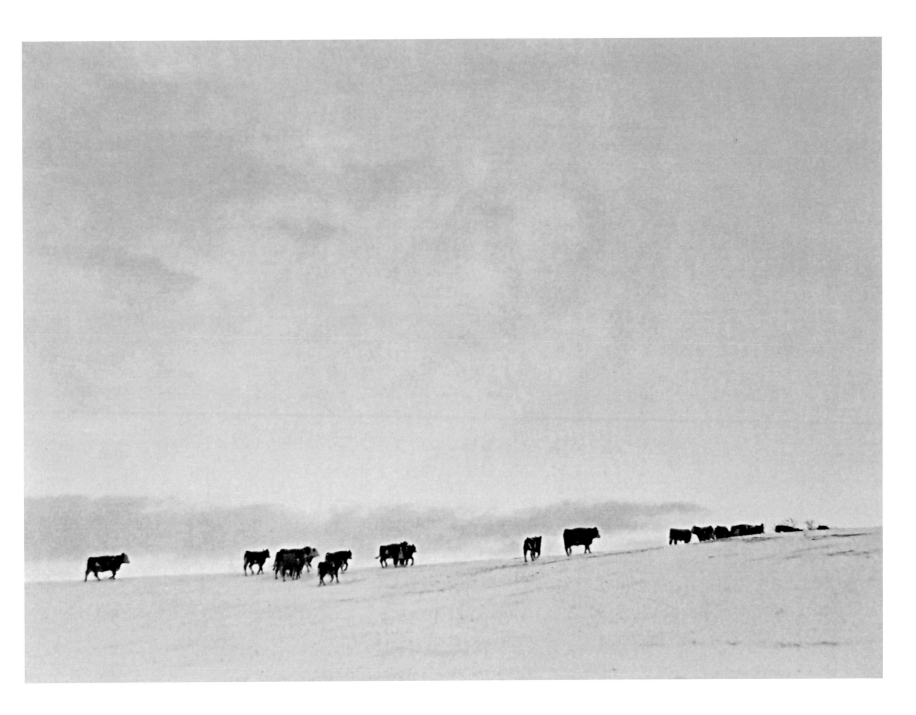

When the cows come home, 2002

Windows to the Soul

Just as a picture can say more than a thousand words, so can a gaze. With a glance of the eyes, we can transmit compassion or hate, seduction or contempt. Gazing deeply into the eyes of another can enable us to touch something intangible, yet profoundly real and deeply moving. In that moment we intuitively feel a connection with their very core and vital spirit…their very soul. This "soul" is an integral part of our conscious awareness, shared at various levels with all other conscious creatures…including cows.

When living creatures, human or otherwise, become aware of and look at each other, there is some level of conscious "soul" appraisal. The glance may be only a cautious safety check or an assessment of the other being's potential for fulfilling a need. Will they harm me or take care of me?

In our natural urge to connect with animals, humans are prone to imbue them with human qualities. We often project onto the animal those parts of ourselves we do not fully recognize as our own, e.g., "That cow looks so secretive and cunning." The inclination to anthropomorphize can be strong and discretion is sometimes needed. Nevertheless, it is evident that we do share realistic common ground in our realm of conscious awareness with animals. The gaze of a bull can be felt when we intrude into his territory. Staring at the bull can trigger a charge. Fear can be seen in the eyes of a cow we have just startled.

In photographing cows over the years, I have been intrigued with what occurs when I first approach them, especially in the early moments of our becoming aware of each other's presence. I look to their eyes and often see what appears to be curiosity mixed with caution. I have made efforts to capture these precious, decisive moments with the camera.

In the images throughout the book, but especially in those that follow, note what you see in the eyes of these cows.

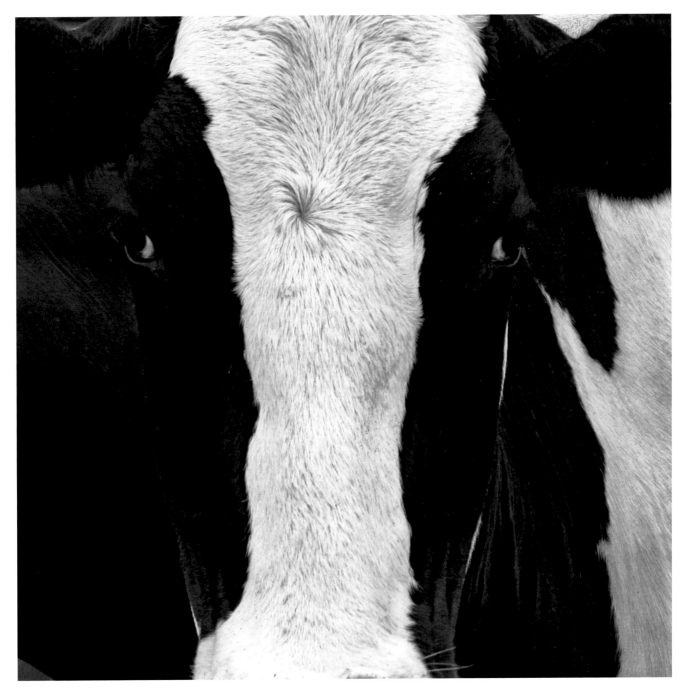

Soul window 1, 2009

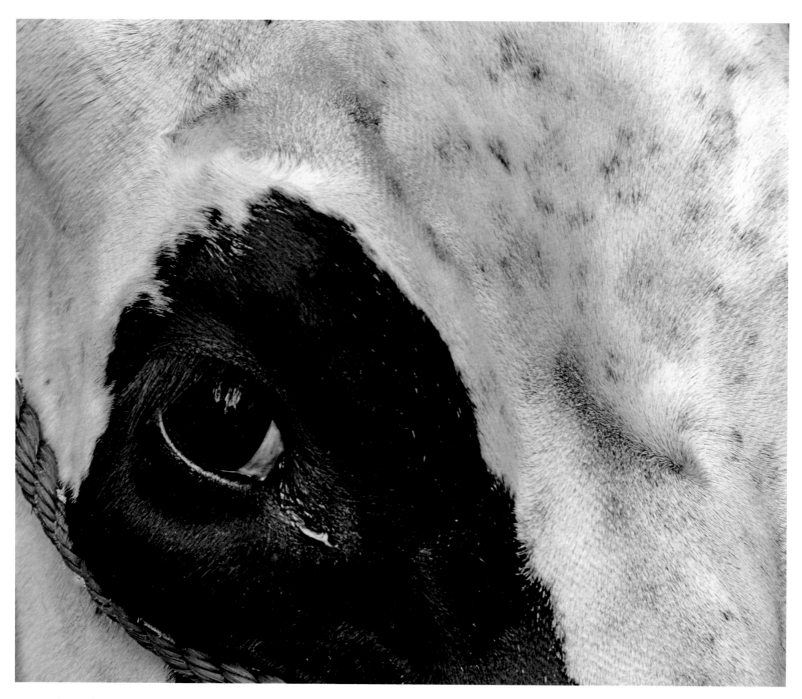

Soul window 2, 2009

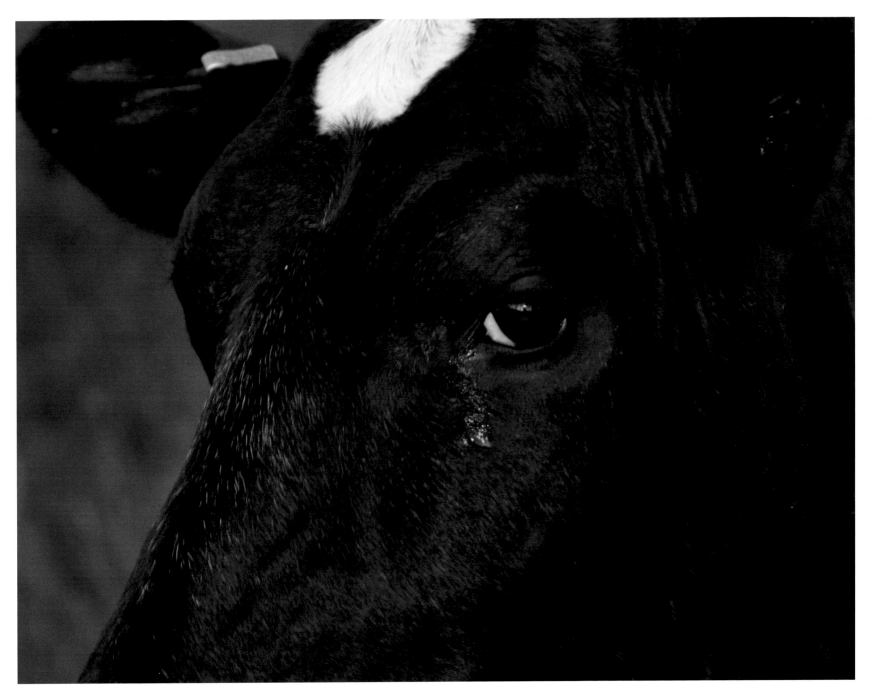

Soul window 3, 2009

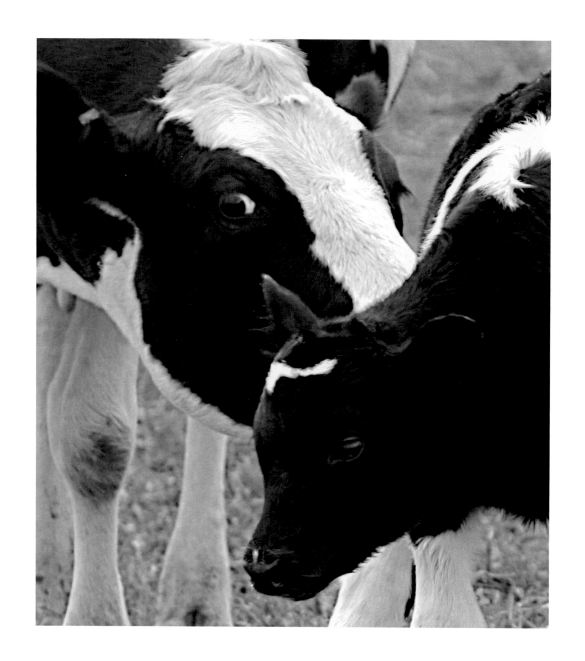

Soul window 4, 2009

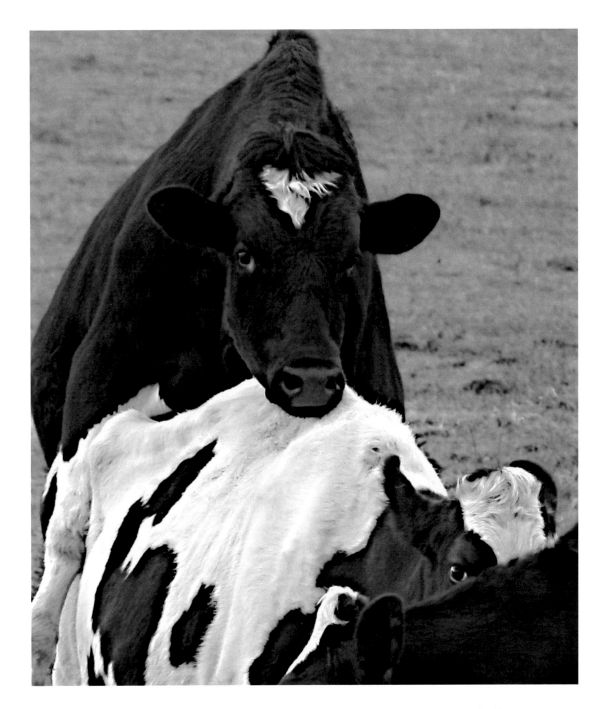

Soul window 5, bull on cow, 2002

Cow Movement in Space/Time

Cows move ... at a cow's pace ... slow, steady, lumbering.

Caution: Watch them long enough and you are likely to find yourself slowing down.

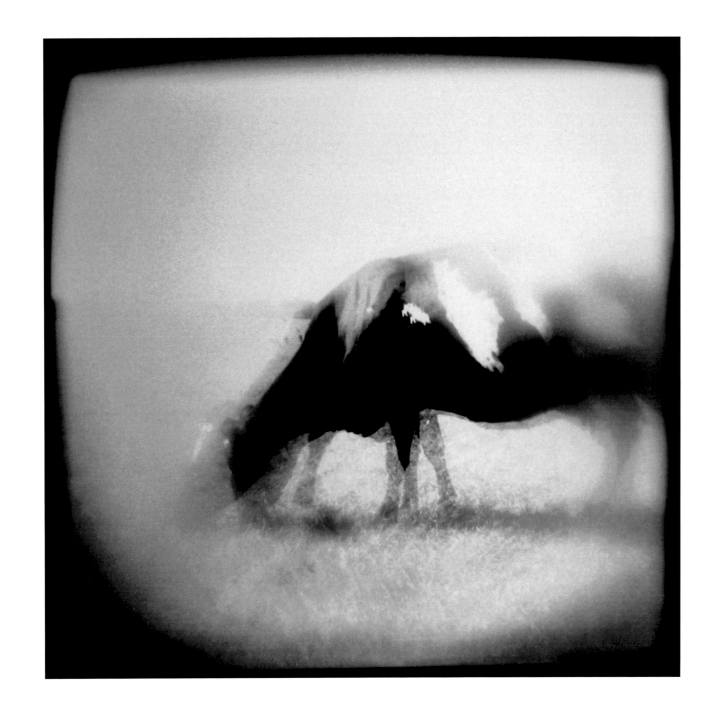

Slow graze 1, 2006

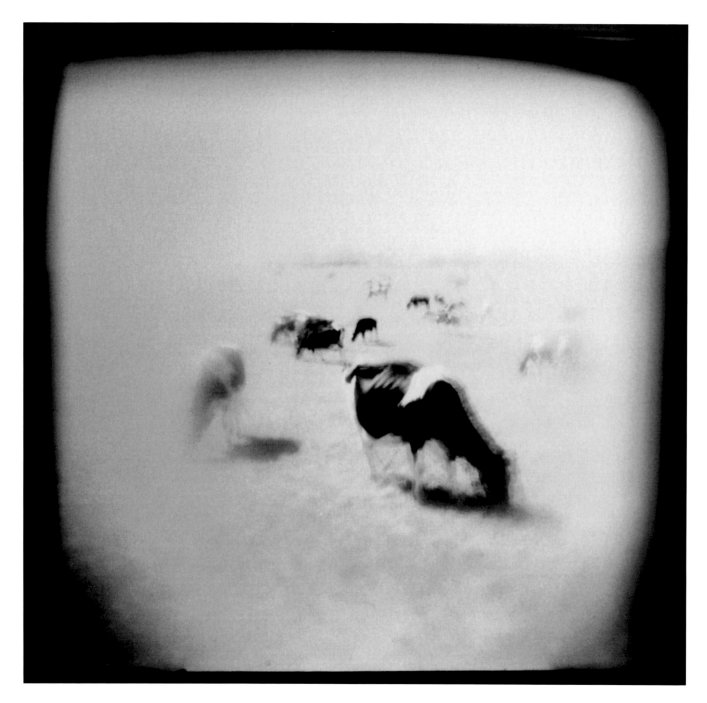

Slow graze 2, 2006

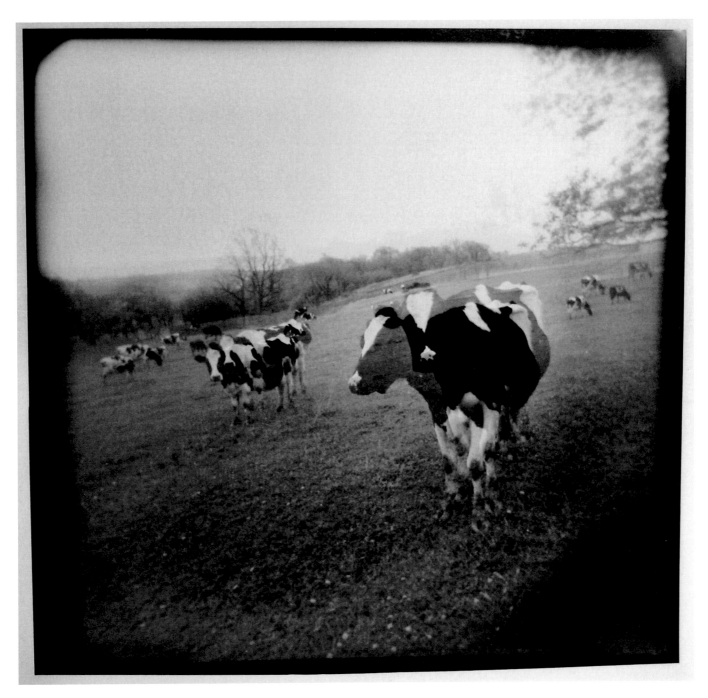

In space/time with cows 1, 2003

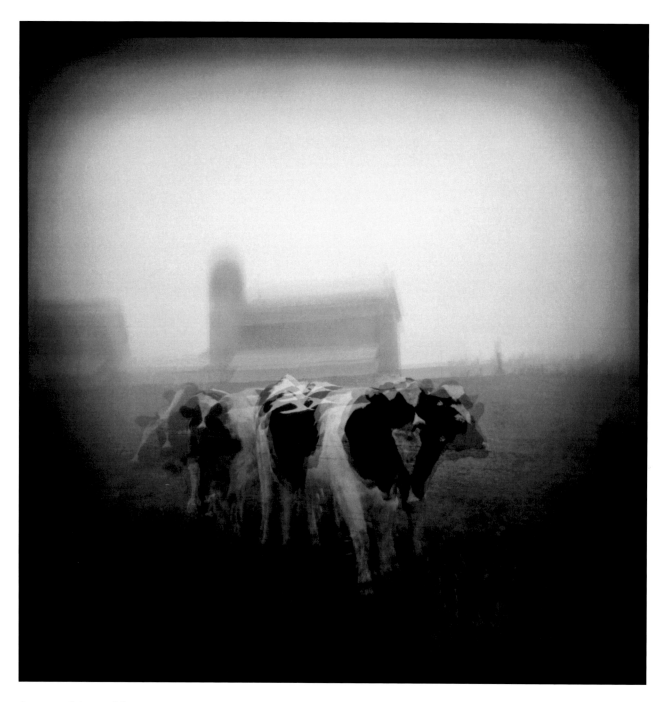

In space/time with cows 2, 2008

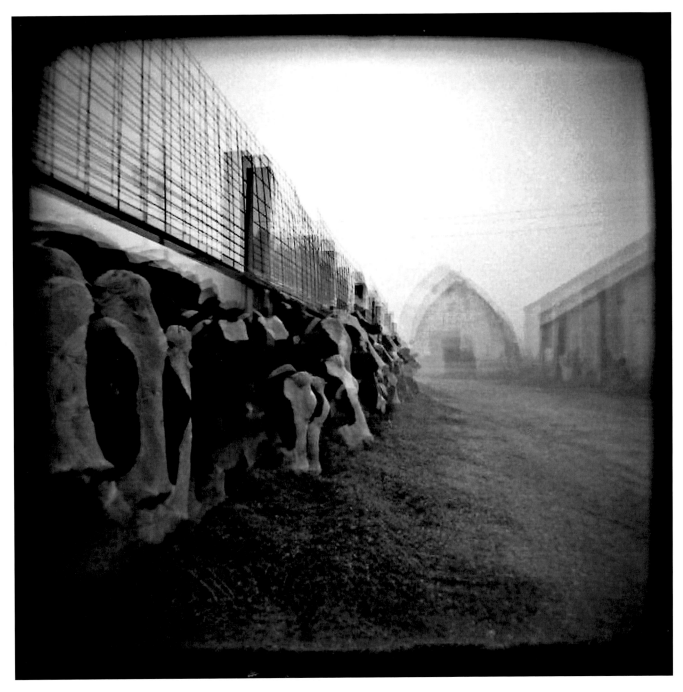

In space/time with cows 3, 2008

Mythical, Mystical, Magical Cow

As we watch a cow grazing in a field, we are not likely to be aware that this animal has historically been revered as a link to the world of spirit. For ages, spiritual teachers have viewed the cow as straddling the temporal and the eternal and have employed them to convey specific religious and philosophical lessons. The cow as supernatural is a cross-cultural phenomenon:

– In the legends of Egypt and Greece, bull power and cow fertility are the essential qualities of bovine gods and goddesses.

– From early Roman Empire times to present-day Ethiopia, cattle intestines, with the natural configuration of a spiraling labyrinth, have been read to predict the future. The labyrinth form appears even earlier in the cave prison of the man-bull minotaur Asterion of Greek legend. Scholars have identified these as prototypes for the labyrinthian walkways used for centuries up to the present time in the meditative, prayerful practices of virtually all spiritual traditions (see page 129).

– Germanic holy men of pre-Christian Europe used sacred runes depicting cattle for promoting fertility and good health. Celtic shamans used bull hide for inducing "bull sleep" that produced prophetic dreams.

– In Scandinavian legend, the cosmic cow Audhumla emerged at the birth of the universe supplying four streams of milk to sustain all living creatures thereafter. Her body parts eventually formed the world.

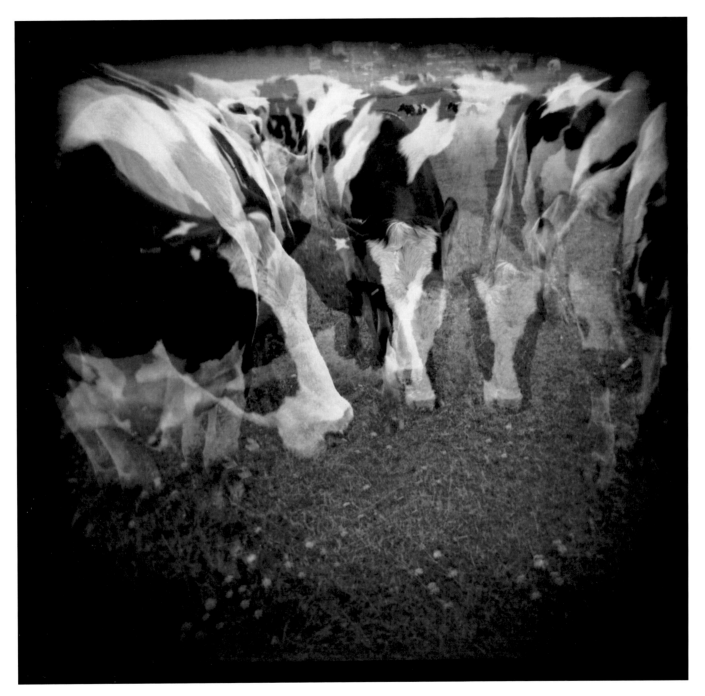

Mystical cow 1, 2005

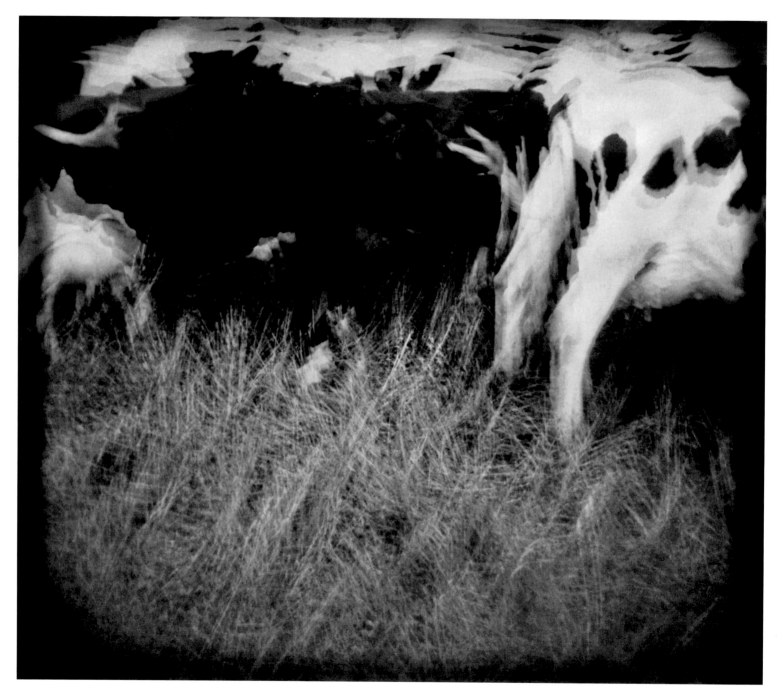

Mystical cow 2, 2005

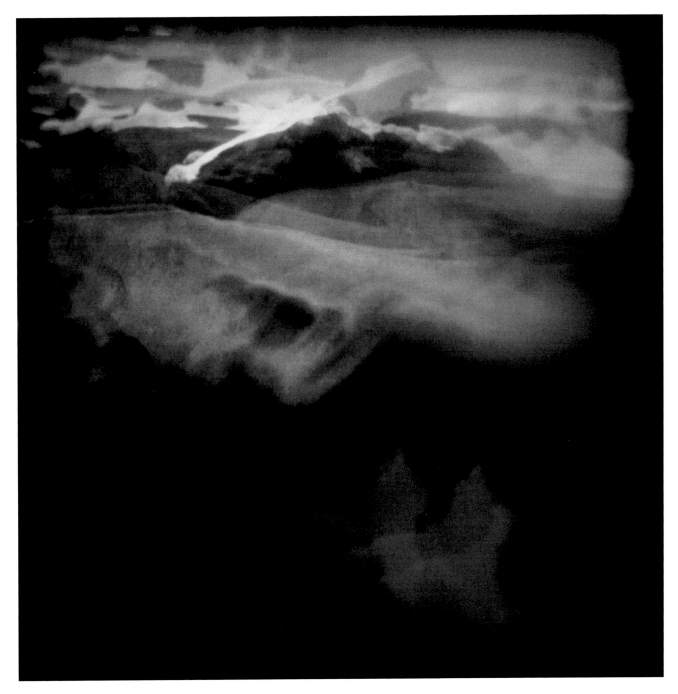

Mystical cow 3, 2005

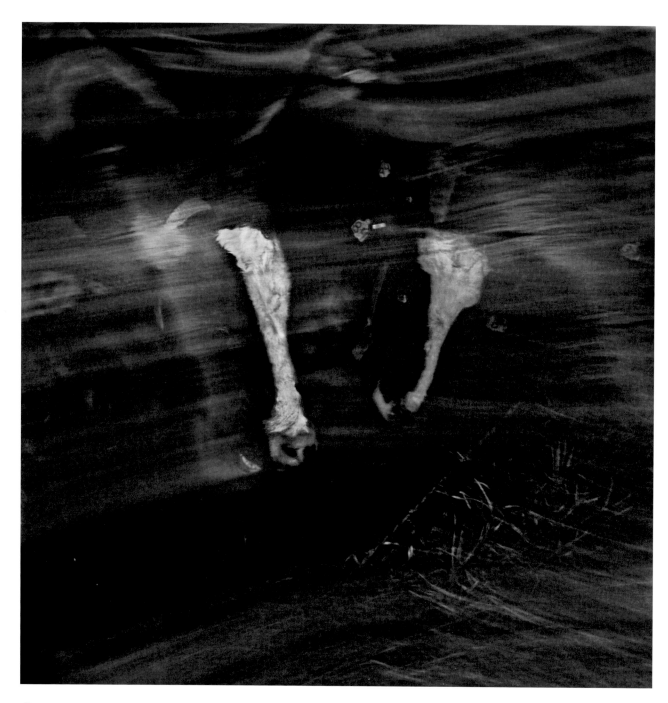

Cow mystery 1, 2009

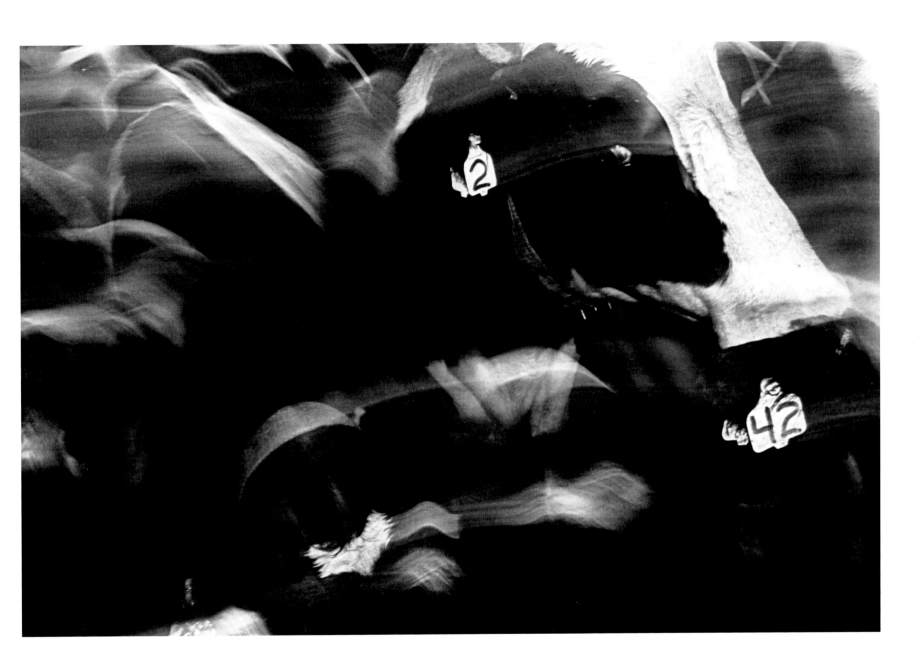

Cow mystery 2, 2009

Spiritual, Sacred, Supernatural Cow

Sacred cow. Holy cow. Part of our everyday language. Perhaps more than any other animal on earth, the cow has played an important role in the lessons and beliefs of every major world religion.

~ Hebrew, Christian, and Islamic sacred writings and traditions have discouraged cow worship and sacrificial practices, yet cows are integral in the teaching of spiritual lessons. Miraculous cow stories are an essential element in the legends and teachings of many saintly Christians of Europe and the British Isles, including Saints Brigid, Kevin, Naile, and Patrick.

~ Perhaps nowhere more than in Hindu India have cows been regarded as supremely sacred. They often embody the highest level of reincarnation, as exemplified by the cow deity Surabhi. Cows are believed to bring good fortune, have powers of purification, and breathe peace into a household. To sell or kill a cow is punishable in this life and the next.

~ Within the perspective of Buddhist traditions, cows are viewed as reincarnated, conscious sentient beings that dwell in pure, simple, present moment awareness.

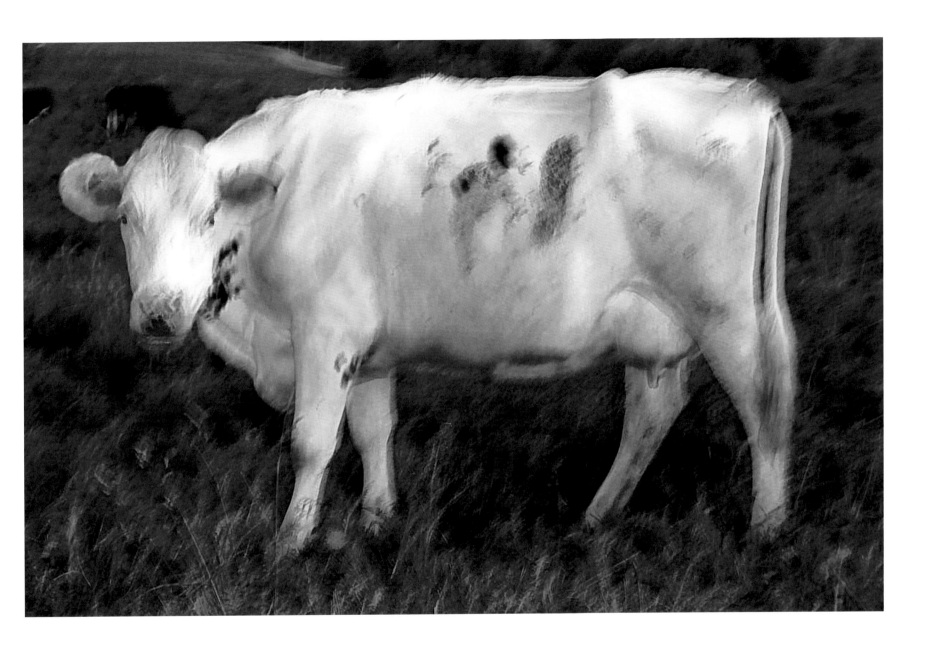

Cow spirit 1, 2009

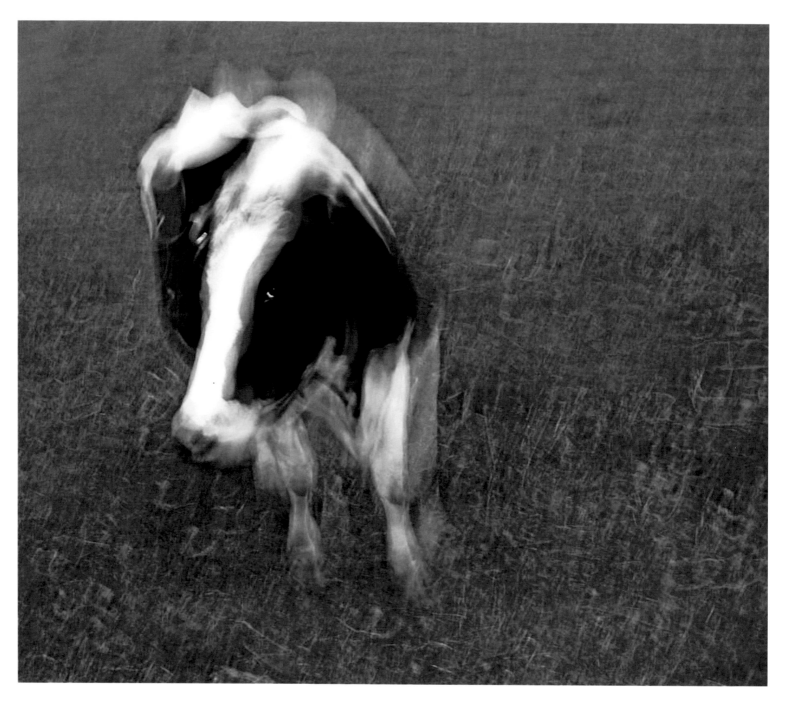

Cow spirit 2, 2009

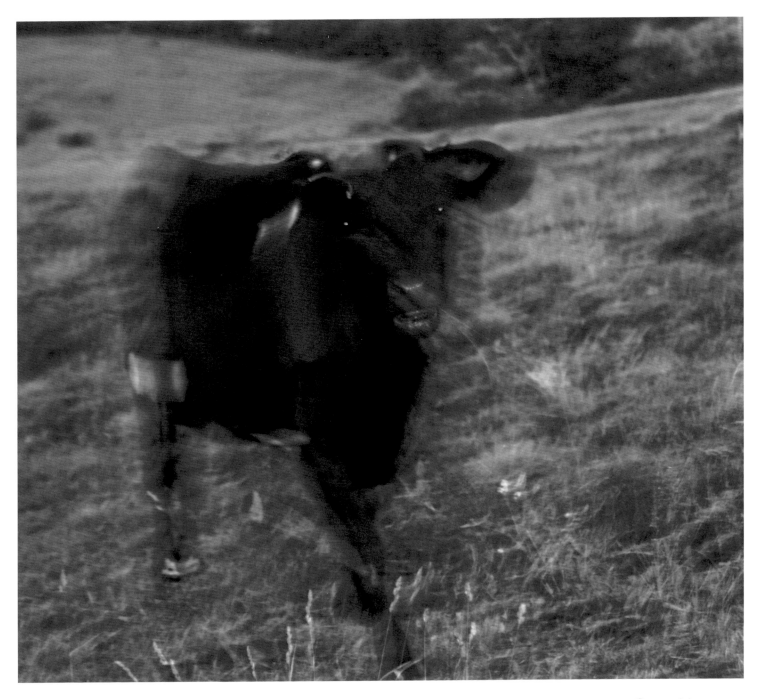

Cow spirit 3, 2009

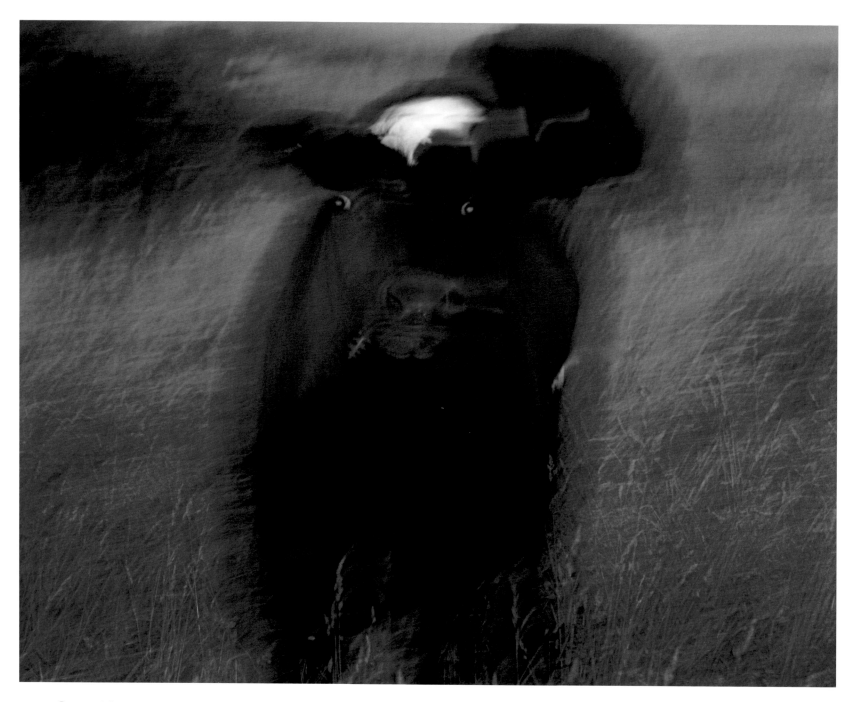

Cow spirit 4, 2009

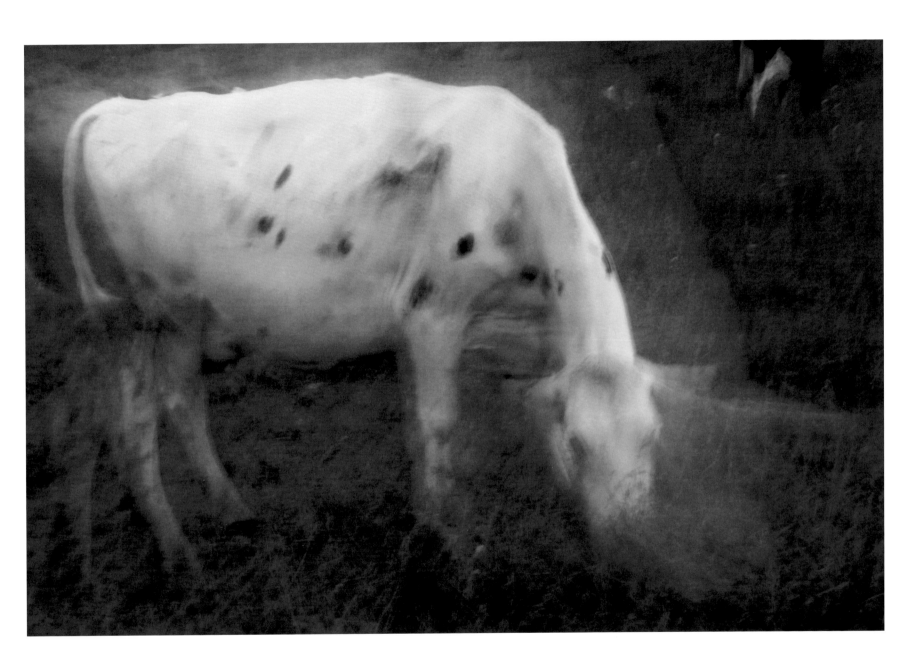

Cow spirit 5, 2010

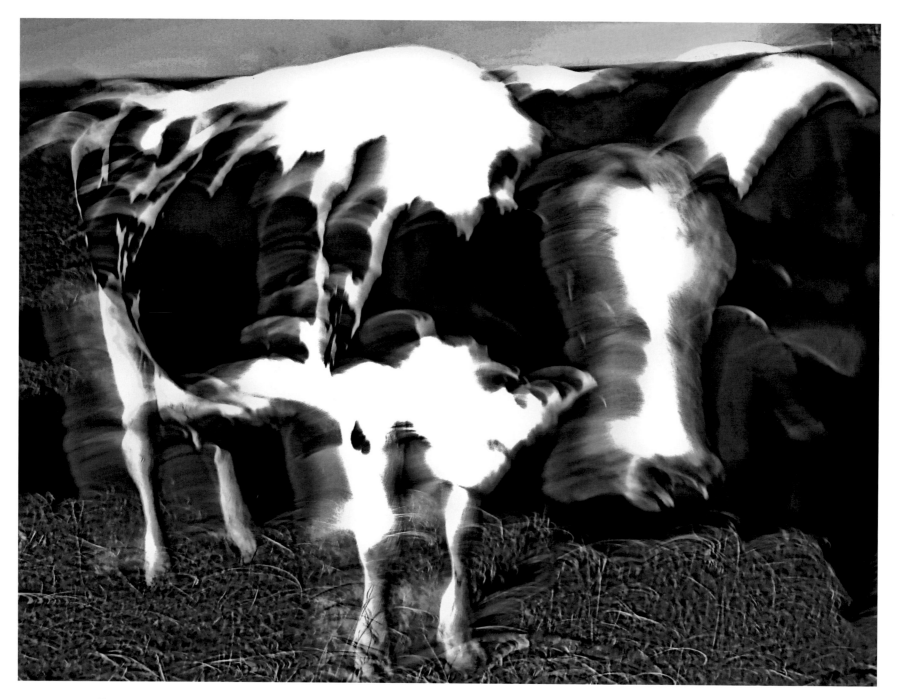

Cow spirit 6, 2009

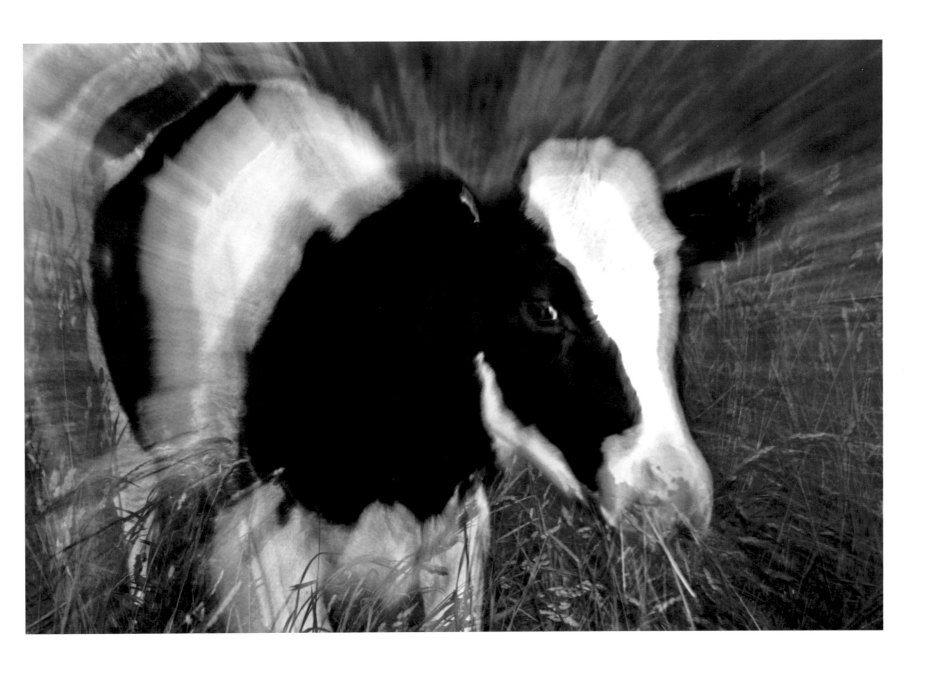

Cow spirit 7 heifer, 2009

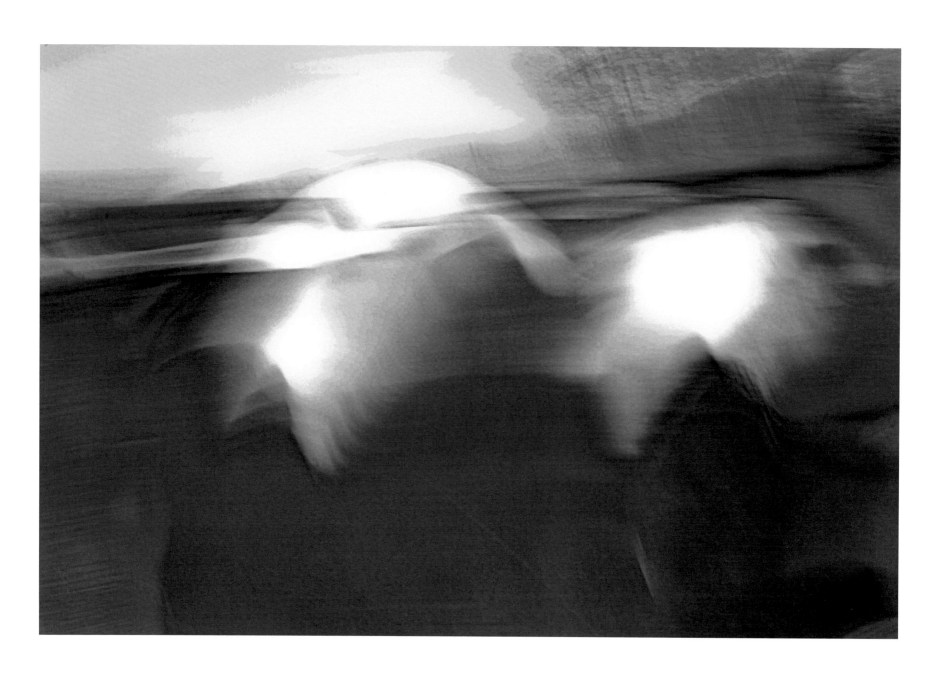

Spirit of cow. Cowscape, 2008

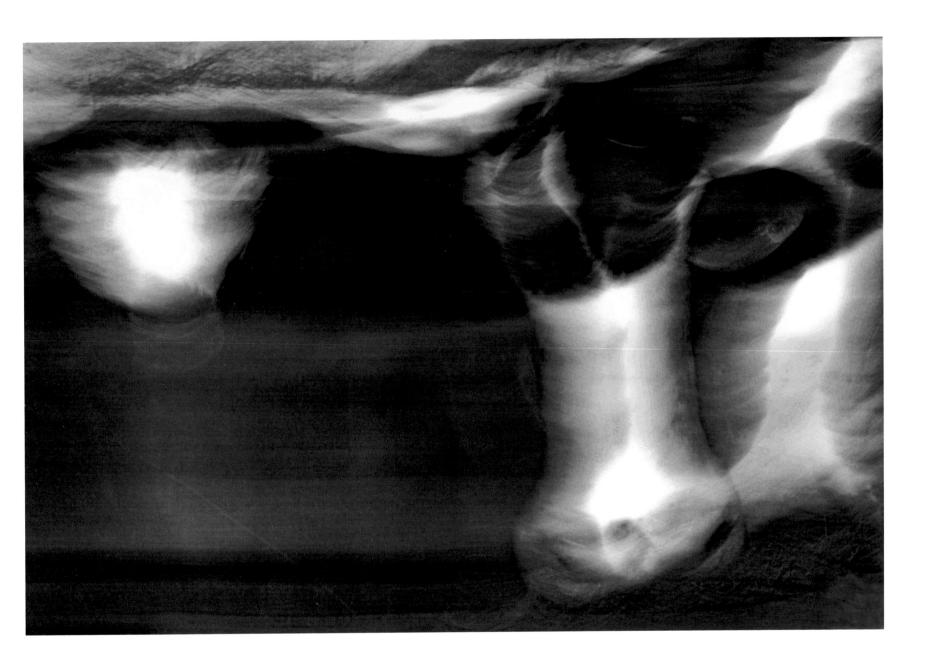

Cow spirit 8, 2008

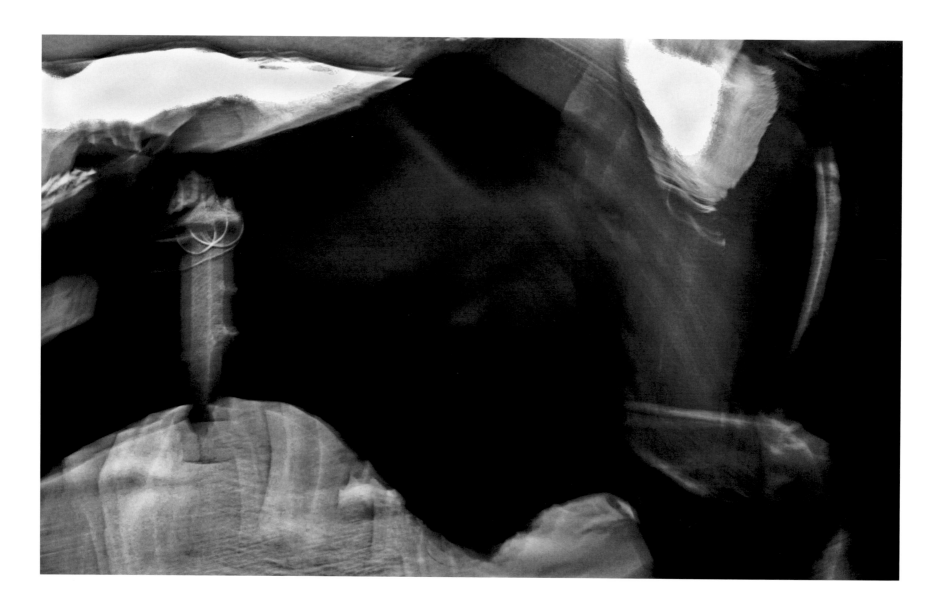

Cow spirit 9, 2009

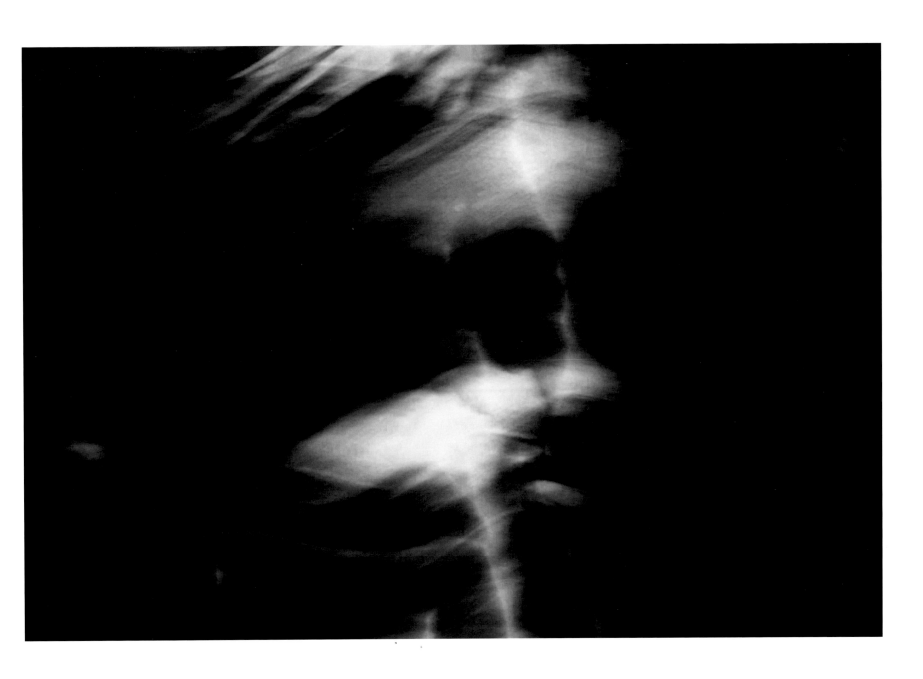

Eternal spirit of cow 1, 2008

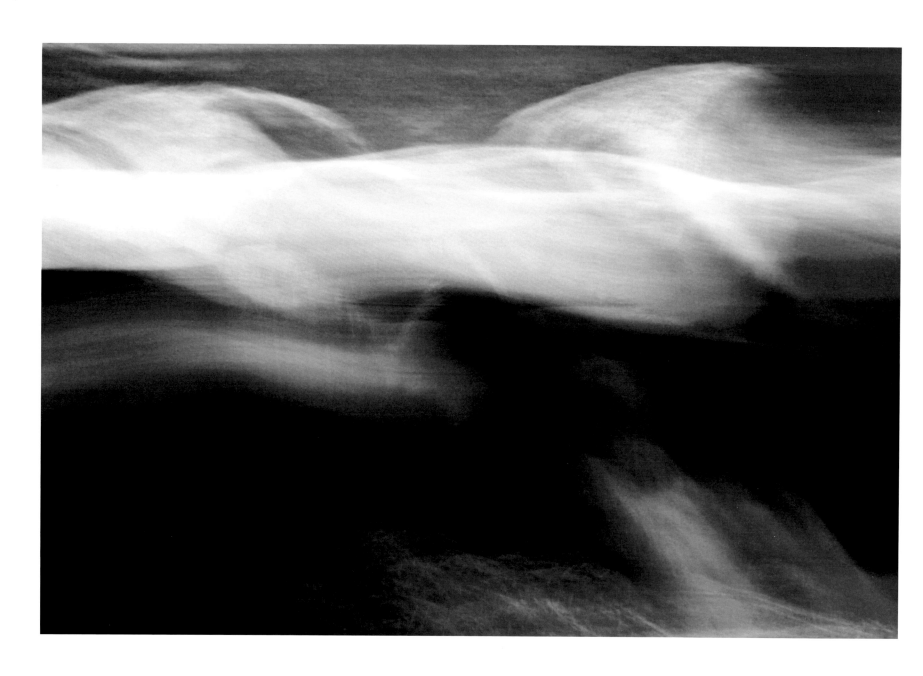

Eternal spirit of cow 2, 2009

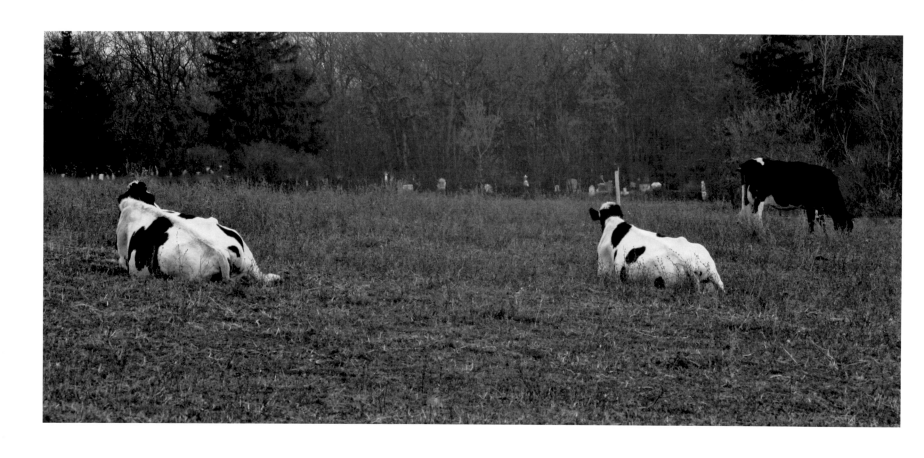

Afterwards, 2009

Afterwords

Preliminary Guidelines for Photographing Cows

The process of photographing cows begins with steps for respecting a farmer's property and your safety:

1. If you need to be on private property, it is wise to ask permission to photograph their animals and/or be on their land.

2. Unless you are experienced in being in the close vicinity of cows and have the owner's permission, stay on the outside of the fence. If there is a bull present, stay well outside the fence. They are often dangerous and unpredictable. Cows are not normally aggressive, but because of their size and sometimes capricious movements, they may accidentally step on a foot or bump you to the ground. Even if you are on the outside of the fence, cows will usually come close enough to be photographed.

3. Move slowly. Sudden movements can startle them and prompt them to move away.

4. As a gesture of appreciation to the farmer, come back, show him your photos, and offer him one or more prints of the cows that you think he might enjoy.

Guidelines for Encountering a Cow

How to Meet a Cow in the Here and Now

Encountering an individual cow can be a powerful experience, especially when done with full attention.

Once you have found an observable herd and taken steps to respect the farmer's property and honor your own safety, choose a spot and wait for the cows to approach you. They rarely will ignore you completely. So if you wait patiently they will come, often eagerly and in earnest. Cows are naturally curious, so be prepared for some intense moments of investigatory sniffing and licking. While it may be tempting to interpret this behavior as evidence of their adulation and enjoyment of your company, it is more likely to be related to their having learned that the presence of a human usually means something good is about to happen: e.g., nourishment or udder relief. A cow will typically explore that possibility for a while and if not forthcoming, unlike a dog or a cat, may lose interest and move on.

From among the cows that approach, select one to observe. Or she may select you. Carefully note the first moments of becoming aware of each other's presence. Attend to and appreciate any eye contact. Close your eyes for a moment and savor the sounds and scents.... If you can safely do so, feel the cow's hide, noticing the texture and temperature.... Study her movements and postures.... Take a few deep breaths.... Notice how you feel now.

If you are an adventurous spirit and open to taking the encounter to a deeper level, try the following at a slow, easy pace, pausing between steps: Carefully observe the cow's breathing for a few more moments.... Now notice your own breathing.... Bring your attention back to the cow's breath and allow your breathing to become synchronized with that of the cow's.... Continue this for about one minute.... Note what happens inside... your own body sensations.... Notice how your connection with the cow feels in this moment.

Guidelines for Enhancing Creativity

There are at least 101 ways to photograph cows. All require giving attention to details necessary in the making of a fine photograph, that is, the intention for making the photograph, knowledge about and interest in the subject, camera settings, lighting, composition, et cetera. The specific guidelines I wish to offer here are more relevant to the internal state of consciousness that a photographer brings to any photographic activity. It is a frame of mind that ultimately impacts the quality of the image and can mean the difference between making a good photo and creating an exceptional photograph.

Drawing on the wisdom of Eastern meditative practices such as those of Buddhist-based mindfulness, we know that moments of creativity are more likely to emerge from a quiet mind. I refer to a mind state that is uncluttered with concerns of the past or future. It is marked by a receptive calm that allows greater creativity to arise from a deeper place. It is a state of highly focused attention in which awareness of time becomes suspended. It allows you to access all that you have ever learned and bring together inner resources for what needs to be created in this moment.

Some people seem to naturally know how to shift into this state. Most of us could use some guidelines and practice. Before you begin photographing, try the following for a few moments:

Find a place and comfortable posture in which you can begin to quiet yourself. Take a deep breath and notice how you feel right now.... Allow yourself to begin to slow down.... With the next inhalation, be aware of any tension in your body... and with the out breath, release that tension. If you need to, gently stretch that part of your body.... With each breath in, be aware of your internal energy.... And with each breath out, release another bundle of tension from your body.... Now find the most relaxed part of your body.... Then allow that part to automatically teach other parts of your body to feel like it feels.... Whenever distracting thoughts arise, simply notice them and let them go... remembering that the source of creativity is beyond thought. Bring your attention back to your breath.... Note the calm, alert state of attention that is developing.... You are now ready to see more deeply... more able to fully maximize your skills... able to remember what you had forgotten that will be helpful to you now... better prepared to recognize and capture decisive moments.... And you may begin to recall some of the feelings from other creative moments... even be able to access creative energy that you didn't know existed.

You might be pleasantly surprised by what comes together for you now.

Cows and Labyrinths: From Entrails to Prayer Trails

For millennia, spiraling labyrinths have appeared in myriad forms as symbolic pathways for the prayerful, meditative practices of spiritual traditions worldwide. Scholars found a precursor for the labyrinth in an ancient Roman ritual employing the spiral pattern of ox intestines to reveal mystical connections. However, the earliest prototype has been traced to the 4,000-year-old Greek legend of Theseus and the minotaur. The hero makes a soulful journey down a dark inner maze to a cave center, where he battles and defeats the evil man/bull. He retraces his path back to wholeness and light.

Whether the labyrinth is found in the Hopi symbol of Emergence, a Buddhist Mandala, or the prayer walkway of the medieval Christian Cathedral of Chartres, it serves as an archetypal form for a spiritual journey. The quest follows a difficult, meandering but purposeful path, ultimately leading to enlightenment and freedom.

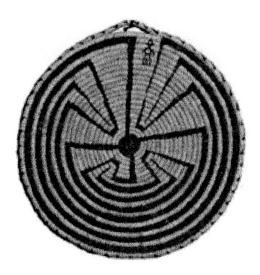

*Native American Hopi
Mother Earth Symbol of Emergence*

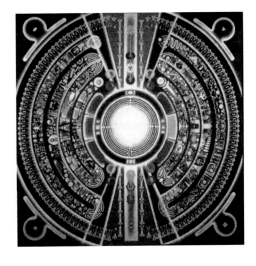

*Star Wheel Mandala (Sanscrit "circle
containing the Essence")*

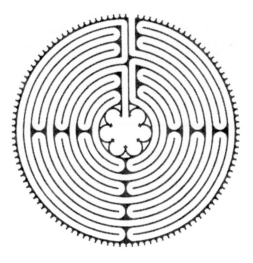

*Chartres Cathedral, France, A.D. 1205
Inlaid floor*

Bovine References and Resources

Books and Periodicals

Recommended for in-depth, comprehensive, and readable books about the cow in history, art, culture, breeds, et cetera.

Rath, Sara. *The Complete Cow*. Stillwater, MN: Voyagur Press, 1998.

Velten, Hannah. *Cow*. Animal Series. London: Reaktion Books Ltd., 2007.

More Specific Cow Information

Dairy Cattle Judging Made Easy. Madison, WI: Babcock Institute, 2004. CD-ROM.

Gonyou, H.W., and J.M. Stookey. "Maternal and Neonatal Behavior." *Veterinary Clinics of North America* 3 no. 2(1987): 231–150.

Ladson, Adelia. "'Cow Whisperer' Links Cow Behavior to Prey Instincts." *Moultrie (Ga.) Observer*, 16 Oct. 2008. moultrieobserver.com

Malven, Paul V. *Mammalian Endocrinology*. Boca Raton, FL: CRC Press, 1993. pp. 229–31.

Pukite, John. *A Field Guide to Cows: How to Identify and Appreciate America's 52 Breeds*. New York: Penguin, 1996.

U.S. Department of Agriculture. *National Agricultural Statistics Service, Dairy Products*. 4 April 2003.

Internet Resources

Dairy Associations, Industry

Answers.com (SIC 0241)

www.dairyfarmingtoday.org

http://www.eatwisconsincheese.com/OtherDairyProductInfo/DairyStatistics.aspx

www.genaust.com/Articles/CowBehaviour.aspx

Cow protection organizations

humanesociety.org Humane Society of the United States

www.iscowp.org

Cow enthusiast Web site with extensive links to cow-related domains

www.crazyforcows.com

List of Photographs

f/gsp: film/gelatin silver print di: digital image H: Holga camera

Acknowledgments

Loving appreciation goes first to Janice, my wife and best friend, who provided extensive support, suggestions, and patient accommodations throughout the course of producing this book.

I am especially grateful to Carol Bjerke, Bruce Allison, David Haskin, and Dennis Trudell, who were most generous with their time and energy in reviewing the manuscript and providing enormously helpful feedback.

Helpful consultation was also received from Sam Abell, Andy Adams, Tim Burton, Russell Joslin, Wally Mason, Patrick Nagatani, Elizabeth Opalenik, and Sonja Thomson.

I am indebted to the good people who brought the book through the latter stages to its completion. Deep gratitude to Richard Quinney for his wise guidance, inspiration, and encouragement throughout, to Ken Crocker for his visionary design and preparation of the book for printing, and to Della Mancuso for her expertise in bringing the work through the printing process.

And very special heartfelt thanks to our kind, considerate dairy farming neighbors; the Duersts, Salisburys, and Schallers, who, by giving me the opportunity to photograph their fine animals, made this photo essay possible.

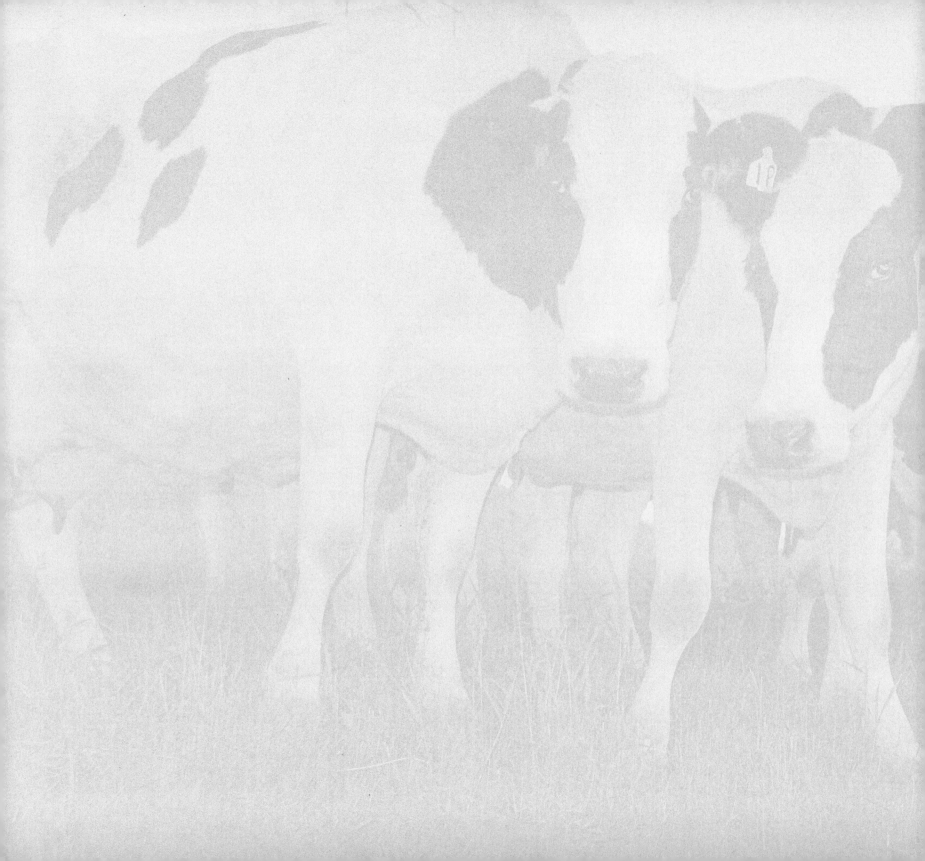